THROUGH DEAF EYES

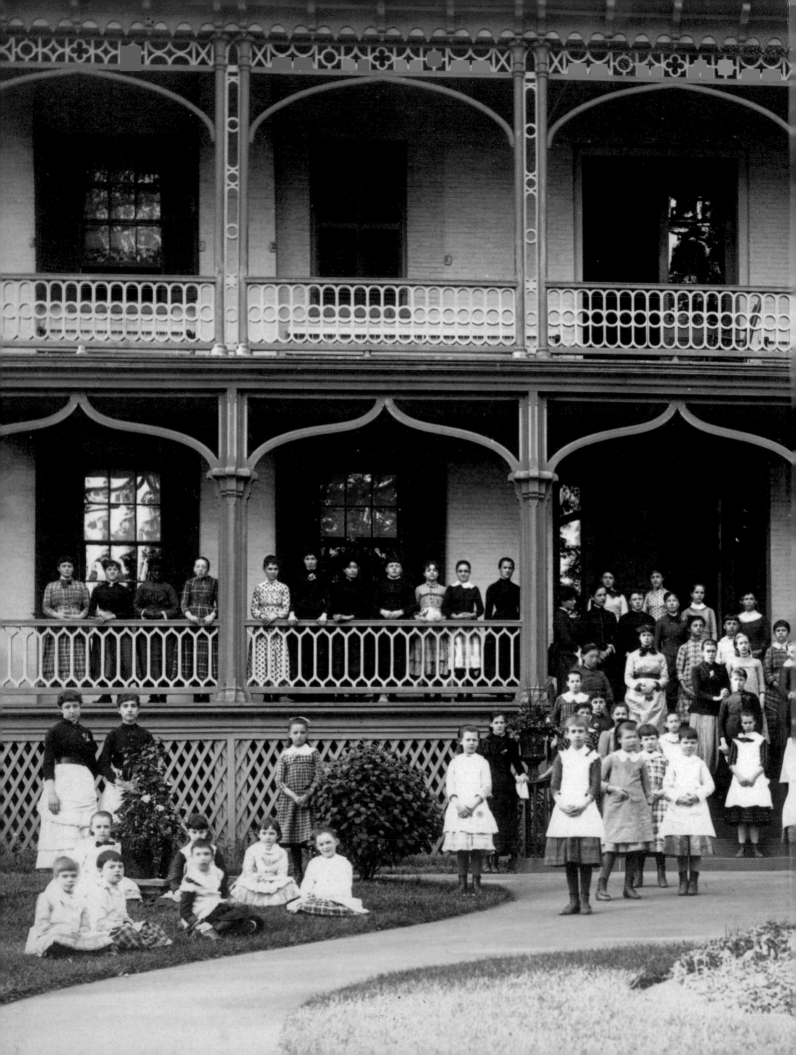

Through Deaf Eyes

A Photographic History
of an American Community

Douglas C. Baynton

Jack R. Gannon

Jean Lindquist Bergey

Gallaudet University Press | Washington, D.C.

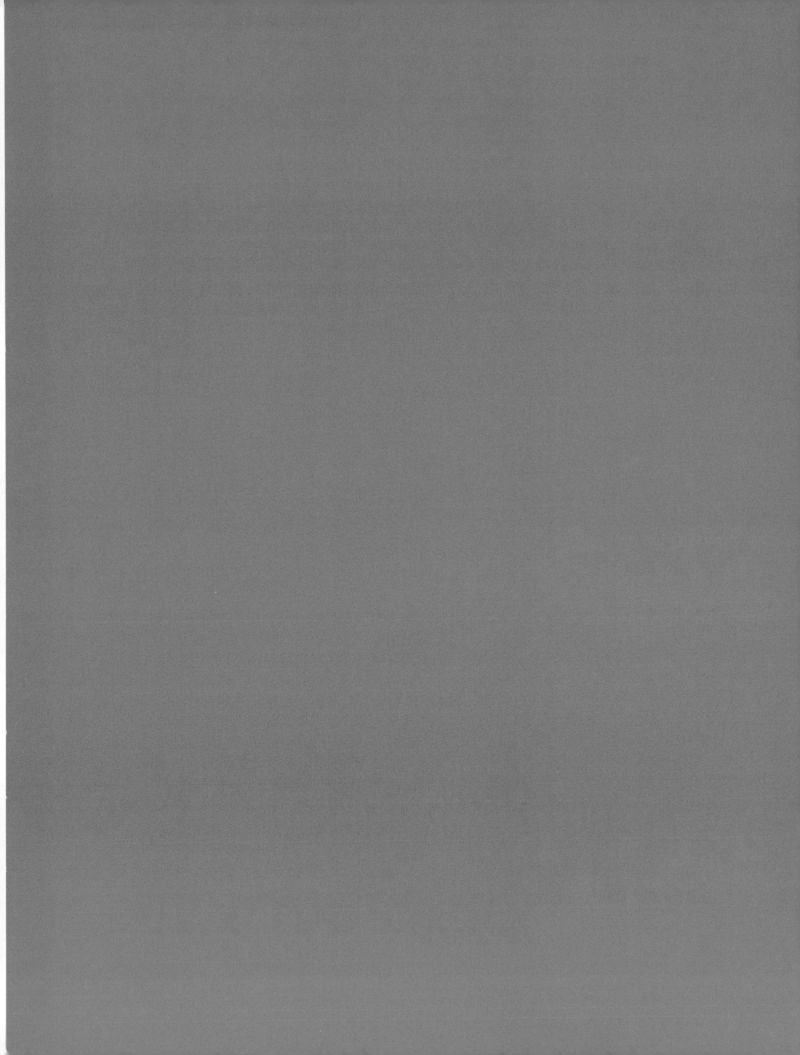

For the Deaf community
and the keepers of our shared history

Preface

History Through Deaf Eyes, an exhibition based on the lives of deaf people in the United States, toured the country from 2001 to 2006. During its twelve-city tour, more than 415,000 people visited the exhibit and learned of the struggles and triumphs of the Deaf community, a cultural, linguistic minority within the larger hearing population. The impetus for History Through Deaf Eyes came from Gallaudet University, the only university in the world founded specifically to provide higher education to deaf and hard of hearing people. Gallaudet is a cultural home to many deaf people. Drawing heavily on the university's extensive Archive collection, the exhibition represents nearly 200 years of United States Deaf history. At each opening of History Through Deaf Eyes, visitors asked, "Where's the book?"

The photographic narrative presented here brings to the public images of people and events both well-known and obscure. The story told in pictures and text reflects the content of the exhibition as well as the focus of the documentary *Through DEAF EYES*, a film produced by WETA TV, in Washington, D.C., and Florentine Films/Hott Productions in association with Gallaudet University, and nationally broadcast on PBS stations. Quotes from the film punctuate this photographic history, and images found within these pages can be seen in the documentary.

NOTE: The word *deaf* has both physical and cultural meanings. In this book, we will use *Deaf* to refer to cultural entities and concepts: Deaf community, Deaf culture, Deaf club, and Deaf lens, for example. We will use *deaf* for all other references.

Studying the lives of deaf people illuminates not only a minority community but also the majority hearing population. Through the story of deaf America we learn much about our broader history. While the values and judgments of society have had an impact on the education, employment, and family life of deaf people, historical eras often can be illuminated by examination through a Deaf lens. For both deaf and hearing readers, the history of the Deaf community offers a unique and fascinating perspective on the workings of human difference.

Photographs often pose contextual questions of where and when. We wonder who took the picture and why; if the setting was staged; and whether the photograph casts a positive image, reinforces a negative vision, or implies multiple interpretations. Each picture was taken for a reason—to persuade others into action, to expose wrongs and misfortune, to present good work, to remember.

Remaining mindful that the photographers may have had different reasons to capture the moment, our intention for this book is to present a community history. For this reason, we selected images that reveal in subtle and obvious ways something about the lives of deaf people and the collective experiences of the Deaf community.

The photographs come from multiple archives held at schools for deaf children and by individual collectors. For each image presented, dozens more did not make it into the book. Still, there are many holes in the photographic record. The photographs we discovered included far more young children

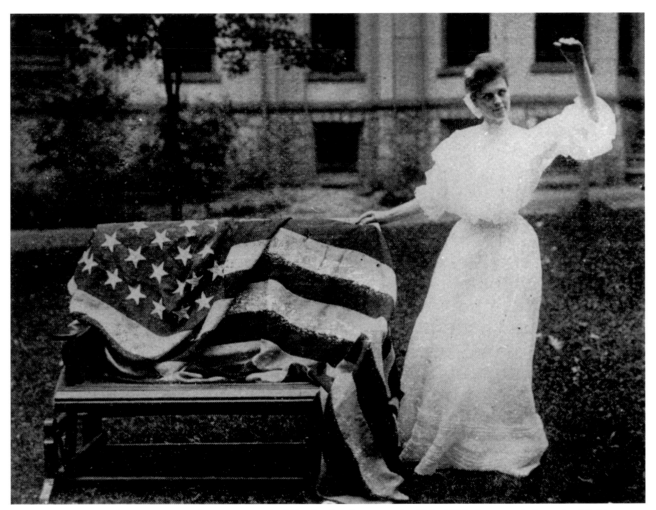

Patriotic themes and imagery were often presented within the Deaf community. This 1906 photograph from the Michigan School for the Deaf shows a woman signing "The Star-Spangled Banner," twenty-five years before it became the national anthem. (Reprinted from *The Silent Worker*, May 1906, Gallaudet University Archives #16006-21, Washington, DC.)

than teenagers or adults, and people of color were conspicuously underrepresented. The nature of deaf leadership historically reflects the larger society, thus we were able to find many more photographs of white men than of women or ethnic/racial groups. It is our hope that this book will prompt more people to come forward with their collections and stories to fill the historical gaps that remain.

CHAPTER ONE

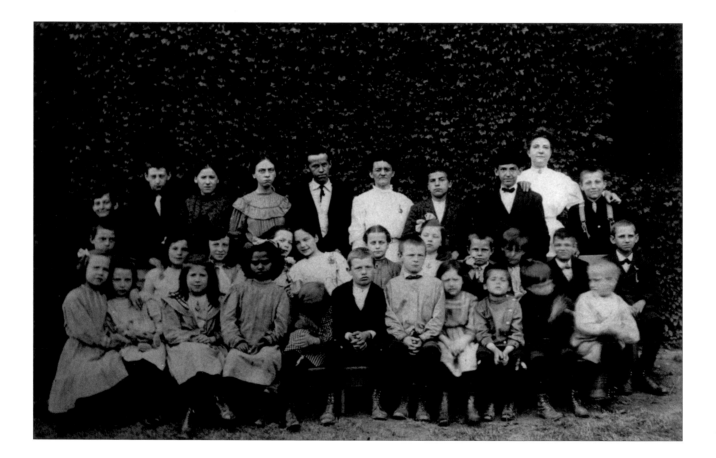

Introduction

DEAF PEOPLE AND VISUAL COMMUNICATION

Human beings are social animals who communicate with each other almost constantly through sounds and movements. From the moment we are born, we are engaged in the learning and use of one or more complex languages. This imperative to employ language is deeply embedded in our genetic heritage. If two infants are placed together in isolation, they will begin to create their own language. So fundamental is the need to maintain communication with others that one of the most severe punishments we can inflict is solitary confinement.

Language is most often conveyed via speech and hearing, but we can just as readily use gesture and sight. Native Americans, for example, created relatively complex gesture languages for intertribal communication as well as for ritual use. Australian aborigines developed sign languages for use when speech was ritually taboo, such as during mourning periods for women or initiation ceremonies for men. Some linguists theorize that humans communicated via gesture for thousands of years before they developed speech.

However, most sign languages, especially the most complex among them, have been developed by Deaf communities. Just as geographical and

◀ In this 1907 school photograph, students and their teacher pose for the camera. All but two of the boys (*first row, right*) are able to be still for the seconds the shutter is snapped. Their signing to each other is captured and produces a double image. (Gallaudet University Archives, #13747-18, Washington, DC; from the Alice Teegarden Album.)

"spoken language" is behind such beliefs, and this makes it difficult to convince people that ASL is a natural language, like any other (whether spoken or signed) that has evolved within a linguistic community.

ASL is often confused with the manual communication systems invented in the 1970s for the purpose of teaching written English to deaf children. These systems attempt to represent English on the hands by adding prefixes, suffixes, and verb-tense endings to ASL signs and by arranging the signs in English word order. "Manually Coded English" systems have their roots in the early nineteenth-century system called "methodical sign language," which was used in the schools in France and the United States. These systems are codes, not true languages.

Because deaf people live among hearing people, they typically are bilingual. Much as Spanish speakers living in the United States sprinkle their conversations with English words and expressions, deaf people introduce elements of English into ASL. They *fingerspell* (use particular handshapes to represent the letters of the English alphabet) many proper nouns, such as personal names, place names, brand names, and titles of books, plays, and movies. They also fingerspell to communicate exact English words. Fingerspelling lies along the boundary of the hearing and Deaf worlds and mediates between English and ASL.

Like spoken languages, ASL is handed down from generation to generation, but this transference occurs most often within the Deaf community rather than in hearing families, in which, typically, there is only one deaf member. Descriptions of signs from the nineteenth century indicate that the language of the Deaf community, which was called "the natural language of signs," has not changed essentially since that time. Films made by the National Association of the Deaf between 1910 and 1921 show deaf people using a sign language that, while different in some particulars, such as the production of certain signs and style of delivery, is understandable

to ASL users today. How has that intergenerational transmission occurred? This brings us to the question of culture.

DEAF CULTURE

Deaf people have formed distinct cultures and signed languages all over the world for at least the last three hundred years. Indeed, wherever sufficient numbers of deaf people have been present, they have formed social groups in which a visually oriented language and culture flourish. These cultures do not include all who lack hearing but rather those deaf people who use sign language, share certain attitudes about themselves and their relation to the hearing world, and identify themselves as a part of a Deaf community. In American Sign Language, this is often referred to as the *Deaf-World*.

What makes Deaf people a cultural group instead of simply a loose organization of people with a similar sensory loss is the fact that their adaptation includes language. An environment created solely by a sensory deprivation does not make a culture. . . . What does form a culture for Deaf people is the fact that the adaptation to a visual world has by human necessity included a visual language. In the United States this is American Sign Language. . . .

This cultural identity is intrinsically bound to the language. When the Northern and Southern soldiers in a Deaf Civil War legend signed what could be glossed as DEAF-SAME, it was not an affirmation of a mutual lack of hearing, but rather one of mutual identity. In fact, in this legend, which continues to be told, it is an identity that transcended North and South allegiances. (Susan D. Rutherford, "The Culture of American Deaf People," Sign Language Studies *51 [Summer 1988]: 725–26, 729)*

The American Deaf community is characterized by a number of cultural attributes, among them the possession of a rich and diverse literature. Like many

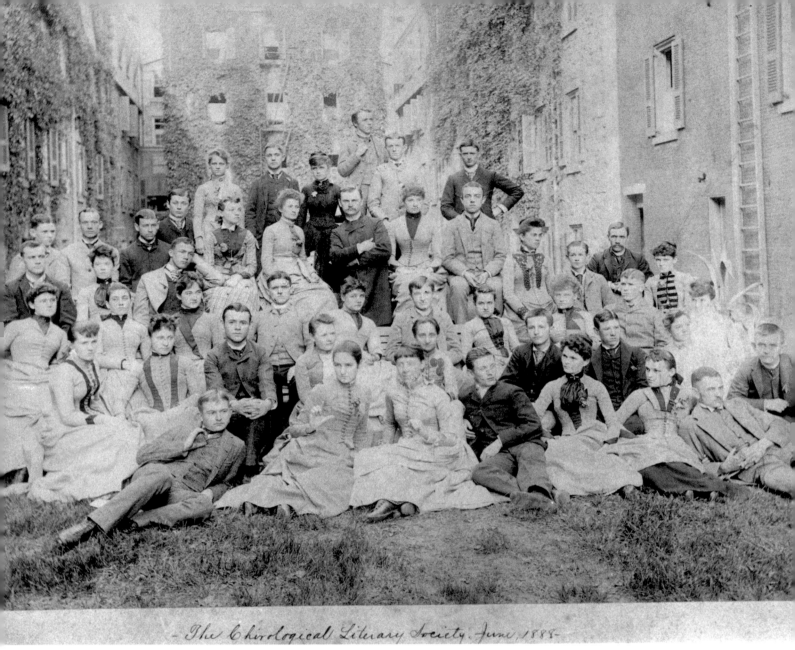

The Chirological Literary Society. June, 1888

Deaf literary societies, such as this one pictured in 1888, were established to provide a place for deaf readers to share their love of written literature. (Gallaudet University Archives, #13145-9, Washington, DC.)

languages spoken all around the world today, ASL does not have a commonly used written form, but it does have a long-standing unwritten literature that includes various forms of oratory, folklore, and performance art. The rhetorical style of oratory is marked by the use of particular, sometimes archaic, signs, and is used for formal occasions. Folklore includes a variety of traditional language arts, such as narratives on traditional themes, jokes and puns, games, and dis-tinctive naming practices. Performance art includes poetry and plays composed in ASL. These genres follow conventions analogous to, but distinct from, those of spoken languages. ASL poetry, for example, is based upon visual rather than aural patterns. This literature has been recorded on film, videotape, and digital media dating back to 1902.

Deaf culture has also been expressed in an astonishing array of social, political, and economic organi-

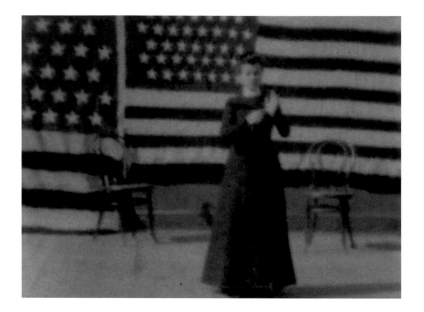

In 1902, American Mutoscope and Biograph company produced "Deaf Mute Girl Reciting 'The Star-Spangled Banner.'" Preserved by the Library of Congress, the film shows an unknown signer presenting a beautiful rendition of what is now the national anthem. (Archival film material from the collections of the Library of Congress.)

zations. The National Association of the Deaf, founded in 1880, currently has active member affiliates in every state. Local clubs have long served as regular meeting places and social centers. The National Fraternal Society of the Deaf was founded in 1901 to provide insurance to deaf people, and over the years it has expanded its operations to become involved in legislative, civic, and social activities. Since 1945, the American Athletic Association of the Deaf has organized sporting events on a national level, as well as American participation in what is now known as the Deaflympics. Dozens of newspapers and magazines written by and for deaf people, with titles such as the *Silent Worker*, *Deaf Life*, and *Silent News*, have existed within the Deaf community over the past century and a half.

These more formal expressions of culture are only the tip of the iceberg. Cultural expression is manifested most importantly in the decisions and actions of everyday life. Deaf cultural norms dictate the rules for the sharing of information, how to politely begin and take turns during a conversation, and appropriate etiquette for social gatherings. When deaf people marry other deaf people (which

they do over 90 percent of the time), that, too, is an expression of cultural values. The transmission of cultural knowledge between generations, which has gone on remarkably effectively in spite of tremendous obstacles, is both the necessary precondition for, as well as the mark of, an enduring culture.

ORAL COMMUNICATION

Lipreading, like sculpting or painting, is an art.
—Bonnie Tucker, *The Feel of Silence*

Deaf people have always communicated by oral means to one extent or another, either exclusively or in addition to sign language. People who lose their

"Do you lipread? That's a very dangerous question, because if you say yes, they talk [way too fast]."

Carol Garretson

"You asked me to speak so I could demonstrate how successful I was as an oral Deaf person. Understand that speaking is only one way and that if I speak, and the other person hears me, they assume that I don't need any sort of interpreting or sign or anything like that. They assume that I can hear them, and that's the problem with speaking. It's one-way communication and that's why I don't. I don't want people to assume that I can hear them—because I can't. It's much easier just to turn off my voice."

Kristen Harmon

"You get dizzy at a meeting trying to locate who is talking and when you finally locate the speaker, he has finished and someone else has started and you must begin your game of 'hide and seek' all over again."

"You drink Manhattans instead of other drinks and you smoke certain brands of cigarettes because your favorites are often difficult to pronounce."

Roy Holcomb, Hazards of Deafness, *quoted in Jack R. Gannon,* Deaf Heritage: A Narrative History of Deaf America *(Silver Spring, MD: National Association of the Deaf, 1981), 210, 216*

hearing in adulthood are less likely to learn to sign or to identify with Deaf culture; however, signers and nonsigners share many experiences, face similar struggles, and work together on many issues. Their combined efforts have contributed to the development of new technologies such as the teletypewriter (TTY) and television closed captioning, and civil rights legislation such as the Americans with Disabilities Act.

"You are at a store purchasing something. The clerk says $3.30 when you think she says $3.13; $3.40 when you think she says $3.14; $3.60 when you think she says $3.16 and any one of the numbers vice versa as well as a thousand and one more confusing words look-alike speechreading words."

Watch yourself in a mirror while you say the following words: bat, bad, ban, mat, mad, man, pat, pad, pan. Most hearing people are surprised to find that every one of these words looks exactly like the others. The cat in the hat may just as well be the hat in the cat. Only 30 to 40 percent of English is unambiguously visible on the lips under ideal circumstances. What would make circumstances less than ideal? Mustaches. Beards. Distance. A speaker who moves around, such as a lecturer. A group discussion. Dim lighting or glare. An old joke about three elderly and hard-of-hearing men on a train points to the difficulties: as they pull into a station, one says, "Ah, it's Weston." The second replies, "I thought it was Thursday." The third: "Me too, let's get a drink."

The challenge of oral communication is to learn to form words and modulate speech patterns with a voice that can be heard only imperfectly or not at all, and to learn to distinguish the words that others form on their lips. Since many words look alike, the lipreader depends also upon body language, context, and other cues to follow a speaker. It is, at best, an imperfect art.

CHAPTER TWO

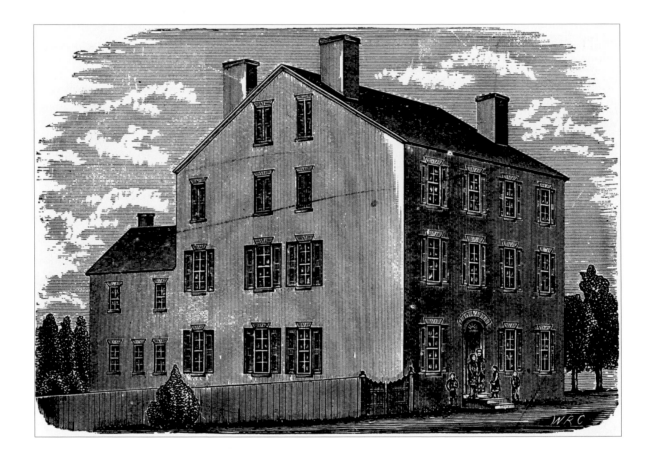

The Advent of Deaf Education in the United States

A PLACE OF OUR OWN

Historical events often appear to have been inevitable or fore-ordained. Look more closely, however, and you find that they were dependent on a chain of arbitrary events. If you could reach back in time and remove one link in the chain, the outcome might have been very different. The story of deaf education in early America, for example, was determined in large part by the fortuitous intersection of the lives of three men—Thomas Hopkins Gallaudet, a Congregational minister without a church; Mason Fitch Cogswell, a physician and the father of a deaf child; and Laurent Clerc, a Parisian teacher deafened in early childhood.

Deaf education might have taken a very different course had Gallaudet not been sickly and, therefore, still living in his family home as a young adult. Gallaudet was an exceptional student. He graduated first in the Yale College class of 1805 at the age of seventeen. Within two years he had earned a master of arts degree, also from Yale, and in 1814 he graduated from Andover Theological Seminary as an ordained Congregational minister. He planned to take a position as a church pastor, but when confronted with poor health, he instead returned to live with his parents in Hartford, Connecticut.

◀ This etching of the second building used for the school that would become known as the American School for the Deaf was engraved by William R. Cullingworth, a deaf artist, in the mid-1800s. (The American School for the Deaf, Hartford, CT.)

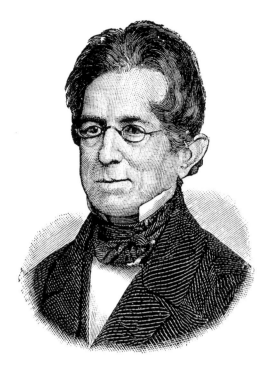

The Reverend Thomas Hopkins Gallaudet was a recently ordained Congregational minister when he met Mason Fitch Cogswell's daughter, Alice, and became interested in educating deaf children. (The American School for the Deaf, Hartford, CT.)

Until this time, wealthy parents had sent their deaf children to schools in Europe. Since no one in the United States had the expertise to teach deaf children, Cogswell and Gallaudet's first priority was to send someone to study the methods used in the European schools. Gallaudet was not eager to go himself, partly because of his frail health and partly because he doubted his abilities. Cogswell persuaded him to go, and helped to raise over $2,000 for the trip. In the summer of 1815 Gallaudet arrived at the Braidwood Academy, a private school in Scotland. He planned to spend several weeks observing classes and studying the Braidwood's teaching techniques. The Braidwood family thought of education as a market commodity, and they considered their techniques, which focused on teaching oral communica-

His parents' neighbor, as it happened, was Mason Fitch Cogswell, a successful and well-to-do physician with a nine-year-old daughter named Alice, who had become deaf at the age of two from meningitis. Gallaudet took an interest in Alice and tried to teach her to read. The story goes that, upon their first meeting on a mild summer afternoon, Gallaudet took off his hat and, using a stick, traced the word *hat* in the dirt. After some pointing back and forth, Alice caught on, copied the word with Gallaudet's stick, and tossed his hat on top of the word. It was the kind of "I think she's got it!" story that every teacher loves to tell, but, as Gallaudet soon realized, learning individual words is only one small part of learning language. He and Cogswell began to explore the possibility of establishing a school dedicated to teaching deaf children. They made contacts with other parents of deaf children and began to raise money.

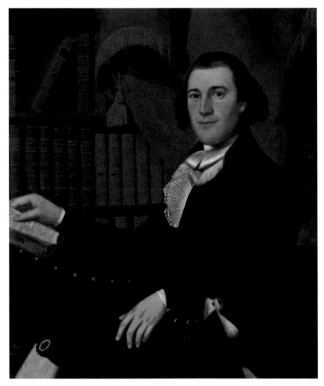

Mason Fitch Cogswell, a wealthy physician and a father in search of an education for his deaf daughter, Alice, helped to found the Connecticut Asylum for the Education and Instruction of Deaf and Dumb Persons, now known as the American School for the Deaf. (Portrait by Ralph Earl, 1791; Museum of Fine Arts, Houston; The Bayou Bend Collection, purchased with funds provided in memory of Miss Ima Hogg.)

tion, to be proprietary secrets that they offered only to a select, paying clientele. Their terms for instructing Gallaudet required that he serve as an apprentice for several years and that he promise never to divulge their methods. Gallaudet refused.

Just at this time, another of those significant accidents of history occurred. Gallaudet learned that the current director of the Royal Institution for Deaf-Mutes was in London. The Royal Institution, a publicly supported school for deaf students in Paris, had been founded in 1755 by a Catholic priest, the Abbé de l'Epée, who had pioneered the use of sign language in the instruction of deaf students. Gallaudet saw a notice that the school's second director, the Abbé Sicard, was giving public demonstrations of his methods with two of his former deaf students—Jean Massieu and Laurent Clerc—both of whom were now teachers at the school. Audiences flocked to see the "educated deaf mutes," a wonder of modern civilization. Sicard would give a lecture and then invite the audience to pose questions to Massieu and Clerc. Sicard interpreted the questions into sign language, and Massieu and Clerc responded not in sign but by writing on a chalkboard in order to display their mastery of written French and, not incidentally, to convince skeptical audiences that their answers really were their own and not Sicard's.

Gallaudet saw his opportunity, attended one of their lectures, and afterward introduced himself to Sicard. As he had hoped, he received an invitation to visit the school in Paris. He spent several months in residence there, much impressed by what he saw. He soon realized, however, that becoming a competent practitioner in this method, which required learning not just a new language but a means of communication radically different from what he was accustomed to, would require him to stay away from home much longer than he had intended. Clerc, who had been a star pupil at the school and was now, at the age of thirty, an accomplished and gifted teacher, offered to return with him to Hartford. Gallaudet, relieved that

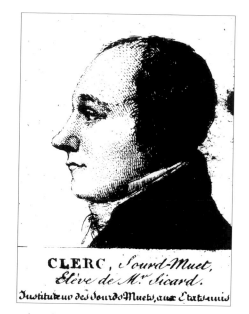

This engraving shows a young Laurent Clerc, "Sourd-Muet" (Deaf–Mute), a brilliant deaf man who was a teacher and former student at the Royal Institute for the Deaf in Paris. Clerc returned with the Reverend Thomas Hopkins Gallaudet to teach students and train teachers at the newly formed American school. (Gallaudet University Archives, Washington, DC.)

someone more experienced than himself would be the lead teacher of the new school, accepted and wrote to Cogswell on January 17, 1816, with the good news.

My dear Sir—Tomorrow I expect to sail from these parts in the Mary Augusta with Captain Hall, for New York, in company with . . . a Mr. Clerc whom perhaps you may have heard of or seen his name mentioned in some of the papers. He is a Frenchman born near Lyons, and ever since one year of age has labored under the same difficulty with Alice . . . Yes, my dear friend, Providence, has most kindly provided for my study and successful return by furnishing me with the most accomplished pupil of the Abbé Sicard and one, too, who is not less recommended by the probity and sweetness of his character, so far as I have been able to ascertain it, than by his rare talents. He already understands a good deal of English. We shall work together on the passage so that he may acquire more. A few months in America will quite make him master of it.

tion, to be proprietary secrets that they offered only to a select, paying clientele. Their terms for instructing Gallaudet required that he serve as an apprentice for several years and that he promise never to divulge their methods. Gallaudet refused.

Just at this time, another of those significant accidents of history occurred. Gallaudet learned that the current director of the Royal Institution for Deaf-Mutes was in London. The Royal Institution, a publicly supported school for deaf students in Paris, had been founded in 1755 by a Catholic priest, the Abbé de l'Epée, who had pioneered the use of sign language in the instruction of deaf students. Gallaudet saw a notice that the school's second director, the Abbé Sicard, was giving public demonstrations of his methods with two of his former deaf students—Jean Massieu and Laurent Clerc—both of whom were now teachers at the school. Audiences flocked to see the "educated deaf mutes," a wonder of modern civilization. Sicard would give a lecture and then invite the audience to pose questions to Massieu and Clerc. Sicard interpreted the questions into sign language, and Massieu and Clerc responded not in sign but by writing on a chalkboard in order to display their mastery of written French and, not incidentally, to convince skeptical audiences that their answers really were their own and not Sicard's.

Gallaudet saw his opportunity, attended one of their lectures, and afterward introduced himself to Sicard. As he had hoped, he received an invitation to visit the school in Paris. He spent several months in residence there, much impressed by what he saw. He soon realized, however, that becoming a competent practitioner in this method, which required learning not just a new language but a means of communication radically different from what he was accustomed to, would require him to stay away from home much longer than he had intended. Clerc, who had been a star pupil at the school and was now, at the age of thirty, an accomplished and gifted teacher, offered to return with him to Hartford. Gallaudet, relieved that

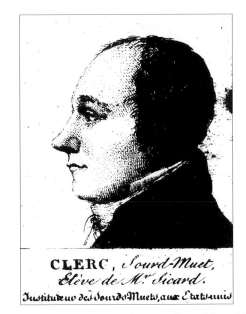

This engraving shows a young Laurent Clerc, "Sourd-Muet" (Deaf–Mute), a brilliant deaf man who was a teacher and former student at the Royal Institute for the Deaf in Paris. Clerc returned with the Reverend Thomas Hopkins Gallaudet to teach students and train teachers at the newly formed American school. (Gallaudet University Archives, Washington, DC.)

someone more experienced than himself would be the lead teacher of the new school, accepted and wrote to Cogswell on January 17, 1816, with the good news.

My dear Sir—Tomorrow I expect to sail from these parts in the Mary Augusta with Captain Hall, for New York, in company with . . . a Mr. Clerc whom perhaps you may have heard of or seen his name mentioned in some of the papers. He is a Frenchman born near Lyons, and ever since one year of age has labored under the same difficulty with Alice . . . Yes, my dear friend, Providence, has most kindly provided for my study and successful return by furnishing me with the most accomplished pupil of the Abbé Sicard and one, too, who is not less recommended by the probity and sweetness of his character, so far as I have been able to ascertain it, than by his rare talents. He already understands a good deal of English. We shall work together on the passage so that he may acquire more. A few months in America will quite make him master of it.

"The school for the Deaf and Dumb here is a very large building of stone. In front of it is a large yard, and behind it a fine garden. There are nearly 90 scholars, boys and girls. I have seen the lowest class several times. There are fifteen boys in it. The master is a Romish Clergyman. . . . In the room are a number of large blackboards, on which the scholars write with chalk. I wrote on these boards and talked with the boys. They understood me very well. One told me he was from the same country as I. But was mistaken. He was from Guadeloupe, an island in the West Indies. Another said he was from the United States, from Georgia."

Thomas H. Gallaudet describing the Royal Institution in Paris in a letter to his pupil, Alice Cogswell, 1816

During the six-week voyage across the Atlantic, Gallaudet tutored Clerc in English while Clerc instructed Gallaudet in sign language. Both were able students; years later Gallaudet would be widely acknowledged as a master of sign language, and Clerc became what one historian has termed "a remarkable stylist" in English. In a letter to Cogswell, Gallaudet wrote of Clerc's diligent study during the long voyage: "I have not the *least doubt* that a few more months will quite make [Clerc] perfect in the more colloquial parts of our language . . . He has not been sick a single day, and has been the most industrious man on board, always at his books or writing."

As soon as Gallaudet and Clerc arrived in Connecticut, they began the work of establishing a school. Cogswell had secured funding and a building. The Connecticut Asylum for the Education and Instruction of Deaf and Dumb Persons (later the American School for the Deaf) opened its doors in Hartford, Connecticut, on April 15, 1817, with Gallaudet as principal and Clerc as head teacher. Clerc's contract stipulated that he would give "his pupils a knowledge of grammar, language, arithmetic, the globe, geography, history; of the Old Testament as contained in the Bible, and the New Testament, including the life of Jesus Christ, the Acts of the Apostles, the Epistles of St. Paul, St. John, St. Peter, and St. Jude."

Clerc brought to America something of greater significance than his skills and knowledge as a teacher, as important as those were—he brought the sign language of Paris. As one of the largest cities in the world, Paris had a large Deaf community and a mature, sophisticated sign language. We know of this community from a book written in 1779 by Pierre Desloges, a deaf Parisian. Desloges wrote that while the conversation of a deaf person living in the provinces was "limited to physical things and bodily needs," a deaf Parisian, through "intercourse with his fellows he promptly acquires the supposedly difficult art of depicting and expressing all his thoughts" in sign language. Desloges and his friends conversed "on all subjects with as much order, precision, and rapidity as if we enjoyed the faculty of speech and hearing." Contrary to what most hearing people might suppose, he continued, "no event—in Paris, in France, or in the four corners of the world—lies outside the scope of our discussion."

"Tracing early Deaf history is a bit like tracing the paths of fireflies. The field is mostly dark, except for scattered moments of illumination. The darkness results in part because manual languages have had no written system, no way of preserving thoughts beyond the moment of utterance. One is always haunted by the sense of how much may have occurred among Deaf individuals and communities throughout history but was never recorded. What we do have are moments of brief but dim lights casting shadows on the existence

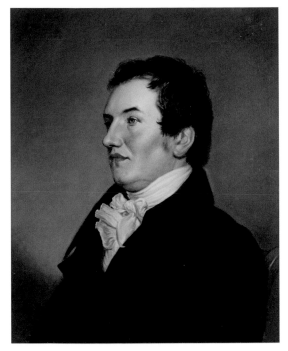

Laurent Clerc brought to the United States the language of the Parisian Deaf community. He taught this language to Rev. Thomas Hopkins Gallaudet and other teachers at the American School. (Portrait by Charles Willson Peale, The American School for the Deaf, Hartford, CT.)

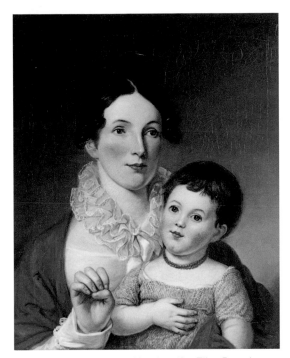

In this portrait, Laurent Clerc's wife, Eliza Boardman Clerc, is signing her daughter Elizabeth's name sign, "E." (Portrait by Charles Willson Peale, The American School for the Deaf, Hartford, CT.)

of signing communities. These appear as hearing philosophers, poets, and artists have come into contact with Deaf individuals and their communities and then wondered in writing about this alternative way of being and thinking in the world. Two and a half millennia ago, for example, Plato referred to a signing Deaf community in Athens in the Socratic dialogue, *Cratylus*. Since then, a number of philosophers and writers—including St. Augustine, da Vinci, Descartes, Rousseau, Leibniz, Diderot, Condillac, and others—have mused about deafness and manual languages. In the end, we are left to connect the dots from one sighting of deafness to the next to form what is a strange type of mute historiography, where the actual lives of Deaf people and signing communities are known only through the writings of others.

It was not until 1779 that a Deaf person, the French printer Pierre Desloges, seized control of the light and turned it toward himself and his community in Paris Had Desloges not committed his thoughts to paper, we would likely have no evidence of a Deaf community prior to the founding of the Abbé de l'Epée's school for Deaf students in Paris. We are left to speculate about how many other signing communities have existed throughout history. How much don't we know and will never know?"

H-Dirksen L. Bauman,
review of A Mighty Change:
An Anthology of Deaf American Writing
1816–1864, *edited by Christopher Krentz,*
Sign Language Studies *2 no. 4 (2002), 452–453*

Clerc's method of instruction had an influence on teachers at the American School for decades. Richard Storrs and Sarah Storrs (siblings) both taught at the "Asylum" that would be known as the American School for the Deaf. Sarah came to the school as a student in 1844. (The American School for the Deaf, Hartford, CT, circa 1866.)

The United States in the early nineteenth century was a rural country with no great cities such as Paris, but it had at least one well-developed sign language. Most of the deaf students who came to the new school at Hartford were from rural areas and knew no sign language; however, some came from Martha's Vineyard, which had an unusually high percentage of deaf people. The islanders had been using sign language for several generations. Between 1825 and 1887, twenty-three students from Martha's Vineyard attended the school in Hartford, and they brought their sign language with them. Other stu-

dents came from families with deaf siblings or parents and would have brought with them sign vocabularies of varying size and complexity. Still others might have brought indigenous sign languages from such cities as New York and Philadelphia. Out of this mix, in which the Parisian sign language of the instructors was dominant, came modern American Sign Language.

Clerc's presence in America was crucial to the founding not just of the Connecticut school but an entire approach to deaf education in America. In subsequent years, he was instrumental in helping to establish schools in several other states, while his former students founded or taught in still more schools around the nation using his methods. Altogether, more than thirty schools were established during Clerc's lifetime. Under his and Gallaudet's influence, all of these early schools adopted what today would be termed a bilingual approach to education, making use of sign language, fingerspelling, and written English.

In addition to the natural sign language that evolved among deaf people, teachers in the early schools also used a system known as "methodical sign language." The Abbé de l'Epée at the Paris school had developed the system as a means of representing spoken French vocabulary and grammar on the hands. In America, Clerc adapted the system to the teaching of English and continued to use it throughout his career as a teacher. Although it was widely adopted in the schools at first, most teachers soon concluded that methodical sign language was too unwieldy for effective instruction and largely abandoned its use by the 1850s.

"Four different modes of communication are employed in conducting the business of instruction. The *first,* on which all the rest are founded, and without which every attempt to teach the

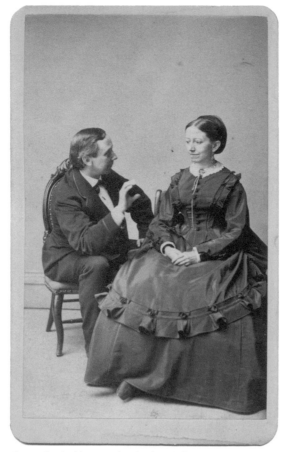

Clerc's method of instruction had an influence on teachers at the American School for decades. Richard Storrs and Sarah Storrs (siblings) both taught at the "Asylum" that would be known as the American School for the Deaf. Sarah came to the school as a student in 1844. (The American School for the Deaf, Hartford, CT, circa 1866.)

The United States in the early nineteenth century was a rural country with no great cities such as Paris, but it had at least one well-developed sign language. Most of the deaf students who came to the new school at Hartford were from rural areas and knew no sign language; however, some came from Martha's Vineyard, which had an unusually high percentage of deaf people. The islanders had been using sign language for several generations. Between 1825 and 1887, twenty-three students from Martha's Vineyard attended the school in Hartford, and they brought their sign language with them. Other stu-

dents came from families with deaf siblings or parents and would have brought with them sign vocabularies of varying size and complexity. Still others might have brought indigenous sign languages from such cities as New York and Philadelphia. Out of this mix, in which the Parisian sign language of the instructors was dominant, came modern American Sign Language.

Clerc's presence in America was crucial to the founding not just of the Connecticut school but an entire approach to deaf education in America. In subsequent years, he was instrumental in helping to establish schools in several other states, while his former students founded or taught in still more schools around the nation using his methods. Altogether, more than thirty schools were established during Clerc's lifetime. Under his and Gallaudet's influence, all of these early schools adopted what today would be termed a bilingual approach to education, making use of sign language, fingerspelling, and written English.

In addition to the natural sign language that evolved among deaf people, teachers in the early schools also used a system known as "methodical sign language." The Abbé de l'Epée at the Paris school had developed the system as a means of representing spoken French vocabulary and grammar on the hands. In America, Clerc adapted the system to the teaching of English and continued to use it throughout his career as a teacher. Although it was widely adopted in the schools at first, most teachers soon concluded that methodical sign language was too unwieldy for effective instruction and largely abandoned its use by the 1850s.

"Four different modes of communication are employed in conducting the business of instruction. The *first,* on which all the rest are founded, and without which every attempt to teach the

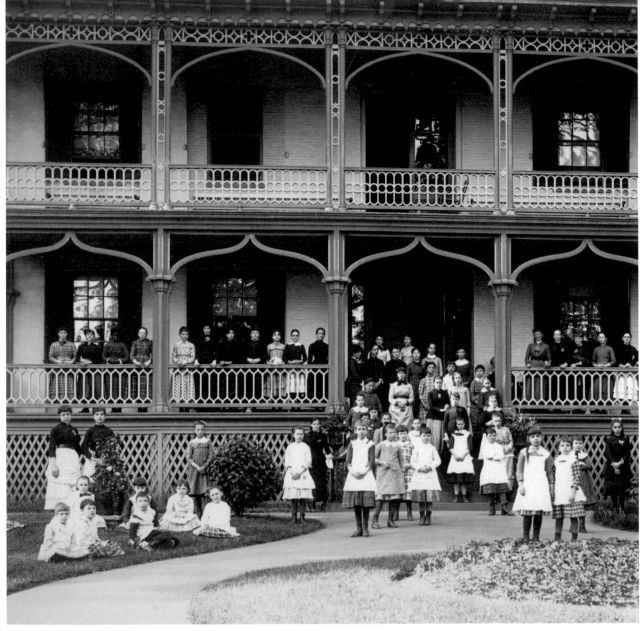

In one of the earliest photos of the American School for the Deaf, girls pose for the student picture in front of the "Old Hartford" building. (The American School for the Deaf, Hartford, CT.)

deaf and dumb would be utterly vain and fruitless, is the natural language of signs, originally employed by the deaf and dumb in all their intercourse with their friends and each other, singularly adapted to their necessities, and so significant and copious in its various expressions, that it furnishes them with a medium of conversation on all common topics . . . The *second* mode of communication is the same natural language of signs . . . reduced to one general standard, and methodized and enlarged by the admirable genius of the Abbé de L'Epée . . . The *third* mode of communication is by means of the manual alphabet. . . . The *fourth* mode of communication is by means of writing."

Third Report of the Directors of the Connecticut Asylum for the Education and Instruction of Deaf and Dumb Persons, Hartford, May 15, 1819

"Every creature, every work of God is admirably well made; but if any one appears imperfect in our eyes, it does not belong to us to criticize it. Perhaps that which we do not find right in its kind, turns to our advantage without being able to perceive it . . . Everything is variable and inconstant. Let us look at the surface of the earth: here the ground is flat; there it is hilly and mountainous; in other places, it is sandy; in others it is barren; and elsewhere productive. Let us, in thought, go into an orchard or forest. What do we see? Trees high or low, large or small, upright or crooked, fruitful or unfruitful. Let us look at the birds of the air, and at the fishes of the sea, nothing resembles another thing. Let us look at the beasts. We see among the same kinds some of different forms, of different dimensions, domestic or wild, harmless or ferocious, useful or useless, pleasing or hideous. Some are bred for men's sakes; some for their own pleasures and amusements; some are of no use to us. There are faults in their organization, as well as in that of men. Our intellectual faculties as well as our corporeal organization have their imperfections. . . . There are faculties both of the mind and heart, which education improve. . . . But nothing can correct the infirmities of the bodily organization, such as deafness, blindness, lameness, palsy, crookedness, ugliness. . . . Why then are we Deaf and Dumb? I do not know, as you do not know why there are infirmities in your bodies, nor why there are among the human kind, white, black, red and yellow men. . . . We therefore cannot but thank God for having made us Deaf and Dumb, hoping that in the future world, the reason of this may be explained to us all."

Laurent Clerc,
Address to the Connecticut Legislature,
May 28, 1818

BEYOND THE AMERICAN SCHOOL

Little is known about the lives of deaf people in America before the establishment of their first school in 1817. Aside from a short-lived effort in Virginia a few years earlier, there had been no systematic effort until then to provide education to deaf children, and since most Americans lived on farms or in small rural towns, most deaf people would live and die without ever coming into contact with others like themselves. In a few cities such as New York and Philadelphia small Deaf communities may have formed, but if so, they have disappeared from history.

With the exception of New England, schooling in America was still largely a private matter in the early nineteenth century. It is not surprising that the first school for the deaf was established in New England, as publicly supported education began there among the Puritan settlers in the seventeenth and eighteenth centuries. In other parts of the country, however, most education still took place in private and church schools, and in the home to the extent that parents were able and willing. Basic literacy among Americans overall was relatively high but varied considerably from region to region. Demand for state-supported public education rose steadily throughout the early years of the nineteenth century.

The scattered population in most parts of the country impeded the development of schools, even for hearing children. The problem was that much worse for deaf children who, outside the cities, were few and far between. The only solution was to bring together widely separated deaf children to live in residential schools. In its early years, students came to the American School from all around the country, but it soon became evident that more schools would be needed as increasing numbers of deaf children were discovered living on scattered farms and in isolated villages. Schools opened in New York in 1818, in Pennsylvania in 1820, Kentucky in 1823, Ohio in 1827, Virginia in 1838, and Indiana in 1843. Within

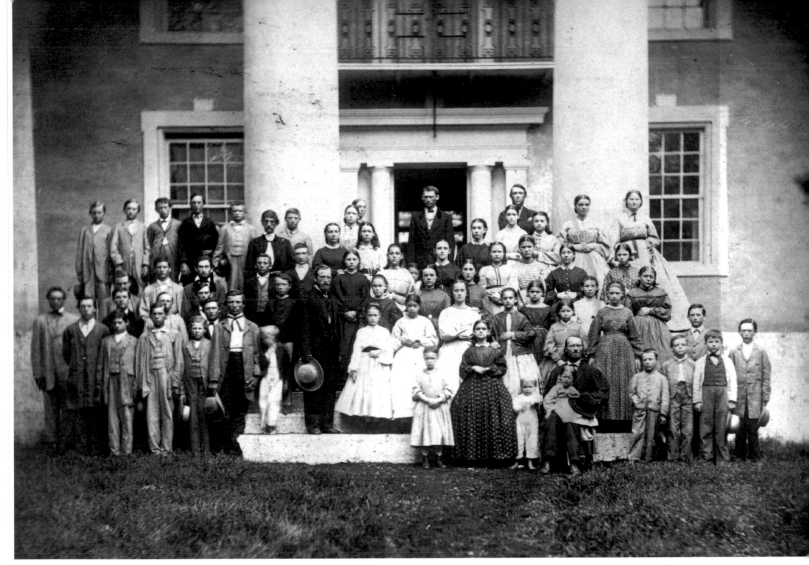

Students and teachers from the Kentucky School for the Deaf, the first Deaf residential school west of the Allegheny Mountains and the first state-supported school, pose on the steps of the main building (ca. 1865). This classroom building, constructed in 1843, also served as a place to hide cows from Civil War soldiers. (Kentucky School for the Deaf, Danville.)

forty years of the opening of the Hartford school, twenty schools had been established, and, by the turn of the century, more than fifty. In larger cities, deaf students might attend local private and religious schools, but the majority of deaf children attended the residential schools. Because transportation before the advent of an integrated railroad system was arduous and slow, deaf children often had to travel for days in coaches and wagons to reach the closest school. Thus, most students remained at school throughout the year, going home only at Christmas and for summer vacation.

Founding Dates of Schools for Deaf Students (1817–1860)

1817	Connecticut	1849	South Carolina
1818	New York	1851	Missouri
1820	Pennsylvania	1852	Louisiana
1823	Kentucky	1852	Wisconsin
1829	Ohio	1854	Michigan
1839	Virginia	1854	Mississippi
1844	Indiana	1855	Iowa
1845	North Carolina	1857	Texas
1845	Tennessee	1858	Alabama
1846	Georgia	1860	California
1846	Illinois		

no idea what to do with their deaf child, and many assumed deaf children to be simply uneducable. Schools therefore had to concern themselves not only with what went on within their walls but also with conducting public information campaigns.

School superintendents first had to convince parents that deaf children could indeed benefit from formal education. To the extent that they succeeded in this, they then had to spend much time corresponding with parents, offering advice on how to educate deaf children during their long preschool years, and supplying parents with appropriate materials. The superintendents especially urged parents to use signs with their children. The schools sent out descriptions of basic signs along with illustrations of the manual alphabet, which was to be taught along with lessons in reading and writing. One of the first books published by a deaf person in the United

Folk Remedies for Deafness

The following list contains some of the methods used by parents, healers, and traditional and alternative medicine providers to cure deafness. Most of these remedies were inserted directly into the ear.

- a gold ring rubbed around the ear
- ants' eggs and onion juice mixed with urine
- cabbage juice
- camphor oil
- castoreum (nutmeg, clove, and cinnamon mixed with whiskey)
- gall of a sandhill crane
- goose grease
- grease from the mountings of a church bell
- grease of a Bittern (Green Heron)
- juice of an onion roasted with a plug of tobacco and mixed with sweet oil
- juice of leaves of wild cucumber mixed with vinegar
- poultice of hot baked onions
- rattlesnake oil
- turtle oil

Source: From the Online Archive of American Folk Medicine, University of California, Los Angeles; http://www.folkmed.ucla.edu

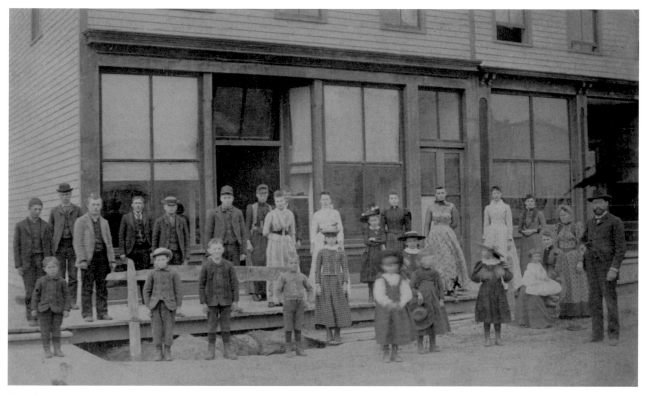

Very few schools started with a campus. The North Dakota School for the Deaf had a store-front building, furnished free-of-charge in 1881 by the people of Devils Lake, ND. (North Dakota School for the Deaf, Devils Lake.)

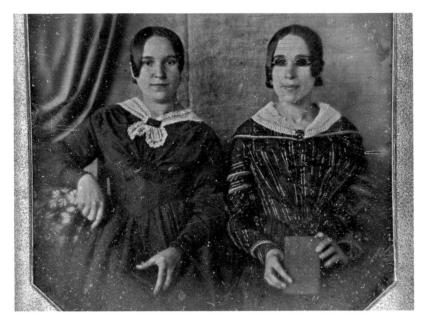

In addition to proving that deaf people could be taught, educators also tried to prove that deaf-blind people could be literate. Laura Bridgman (pictured with her teacher in 1847) became a celebrity when writers and philosophers came to see what she could accomplish. The sample of her writing, "Grace be with you," was used as evidence of her knowledge of letters and of spiritual understanding. (Courtesy of Matthew R. Isenburg.)

States, *Tales of the Deaf and Dumb* (1835), by John Burnet, took pains to explain to parents that their deaf children were just as capable of learning as hearing children, but that what they required first was a language accessible to them.

> *Of the long catalogue of infirmities which flesh is heir to, deafness is the one which is least apparent at first sight, and which least affects, directly, the vigor of the bodily or mental faculties, and yet there is no other infirmity, short of the deprivation of reason, which so completely shuts its unfortunate subject out of the Society of his fellows. Yet this is not because the deaf are deprived of a single sense; but because the language of the hearing world is a language of sounds. Their misfortune is not that they* are *deaf and dumb, but that* others *hear and speak. Were the established mode of communication among men, by a language addressed not to the ear, but to the eye, the present inferiority of the deaf would entirely vanish; but at*

> *the same time the mental and social conditions of the blind would be far more deplorable, and their education far more impracticable, than that of the deaf is now.*

When deaf children reached the age of eight or ten and were capable of focusing their intellects in the fashion educators required, their formal schooling commenced. The residential schools typically had several aims in addition to imparting basic literacy and numeracy. Their faculty was largely drawn from graduates of liberal arts colleges such as Yale College; they, therefore, put great stock in the value of a solid grounding in the humanities. Another goal, one that grew in prominence as the century progressed, was to train students for a vocation and economically productive life. Additionally, the schools saw religious education as central to their mission because, as one educator noted, deaf children often came to school "entirely destitute of a knowledge of even natural reli-

gion, with which the most abandoned tribes of the heathen, it is believed, have some acquaintance."

A VERY SOLEMN RESPONSIBILITY

The character and philosophy of the early schools were fundamentally shaped by the larger cultural context of the time. The early nineteenth century was a time of tremendous social reform, much of it generated by a dramatic transformation in the character of American religious belief. Historians have termed this period the Second Great Awakening, which saw not only an upsurge in church attendance but also the rise to dominance of evangelical Protestantism. The first and most obvious feature of this change was that evangelical ministers did not wait until a town decided to build a church and hire a minister. Instead, they became freelance entrepreneurs, traveling from town to town, often on the frontier or in rural areas, preaching in rented halls or simply outdoors in an open field. These were not small affairs—some open-air revival meetings attracted up to 25,000 people who came from many miles around.

"It will be very gratifying to the patrons and friends of this institution to learn, that through the blessing of a kind providence, its doors are now opened, notwithstanding the numerous obstacles and disappointments which have been encountered from the commencement of our labours. A numerous and interesting family of the unfortunate are already assembled, and we behold those minds which were like a waste hedged about with thorns, now yielding to the cultivation of science, and daily affording promise of abundant intellectual improvement. Are any still skeptical on the subject of promoting the happiness of the deaf and dumb by education? Let them visit the Asylum, and behold the social circle in the evening hour,

delighted in exhibiting those first rudiments of learning which they have already acquired. And let the Christian look forward with a humble hope, that many of these immortal souls may not only be rescued from intellectual darkness, but that they may also be brought to a knowledge of the truth as it is in Jesus, and finally be found among the redeemed of the Lord."

Report of the Committee of the Connecticut Asylum for the Education and Instruction of Deaf and Dumb Persons, Hartford, June 1, 1817

Not only the venue but the message of these evangelical ministers was new. Protestant churches had long emphasized the absolute supremacy of God, the abject powerlessness of human beings, and the doctrine of predestination, which held that only a small minority of people were destined for heaven and the rest for hell. No human effort or deed could change what had been determined by an all-powerful and all-seeing creator at the beginning of time. The message preached by the evangelical ministers, however, was that humans had been given free will and that, therefore, anyone could achieve salvation by *choosing* to believe and to experience conversion.

This was a radical departure and it had radical effects. If individuals could be saved, then it was the responsibility of every believer to convert others and save them from eternal damnation. This belief stimulated not only the revival meetings but a steady stream of missionaries sent round the world—to China, to Africa, to all who lived in ignorance of the Christian gospel and, therefore, of their one chance for salvation. Within the United States there were American Indians to be saved. And there were deaf people.

Many of the early schools for the deaf were conceived as Christian outposts for people who by their deafness were cut off from the gospel. Gallaudet, an

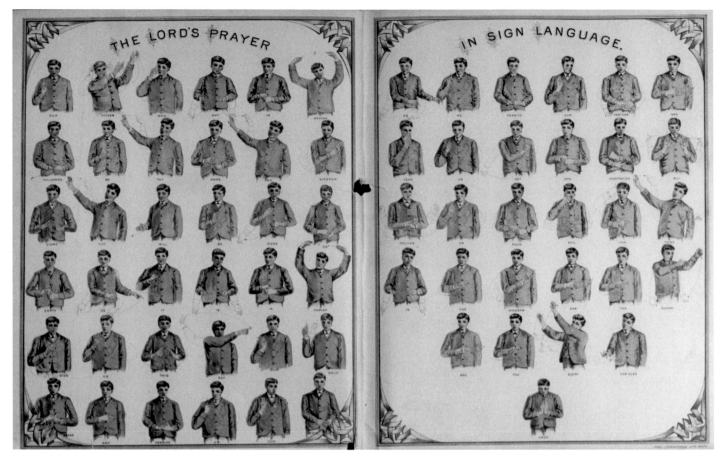

Lithographs were used to teach prayers that were often signed in unison. (Gallaudet University Archives, Washington, DC.)

ordained minister, believed that "no other object than the salvation of souls of the pupils can be named as of the highest moment; and to accomplish this object a very solemn responsibility is devolved upon all who are concerned in the affairs of the Asylum." While this was not the exclusive motivation for all the teachers, many explicitly equated their work with that of the missionary. One wrote that the uneducated deaf people of America may "as well have been born in benighted Asia, as in this land of light;" they represented "a community of heathen at our very doors." The teachers avowed that to teach deaf students "the gospel of Christ, and by it to save their souls, is our great duty." Just as other missionaries learned Native American or African languages and went to preach among the unconverted, early teachers of the deaf learned sign language so that they might bring light into the darkness.

"A cup of consolation for the deaf and dumb who heretofore had been wandering in a moral desert, from the same fountain the Hindoo, the African, and the savage are beginning to draw the water of eternal life."

Thomas Hopkins Gallaudet

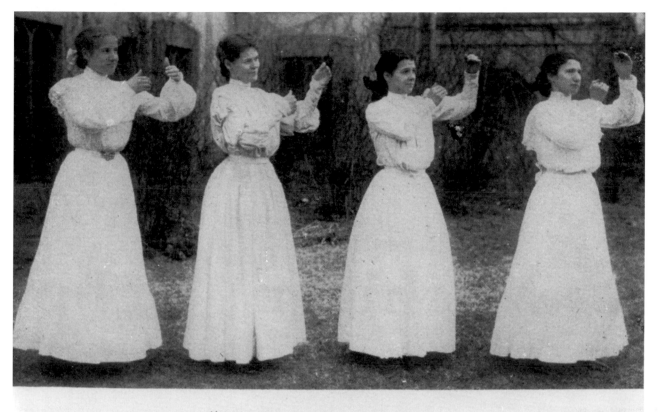

"NEARER, MY GOD, TO THEE."

Public performances of signed songs, particularly religious songs, were popular. Here, students from the Michigan School for the Deaf sign the hymn "Nearer My God to Thee." (Gallaudet University Archives, Washington, DC.)

FROM ASYLUM TO SCHOOL

Early schools for deaf students usually included the words *asylum* or *institution for the deaf and dumb* in their names. Later in the nineteenth century, they began referring to themselves as *schools* to make clear their purely educational function. Similarly, the term *dumb*, which appeared in many early school names and meant simply nonspeaking, was dropped as it began to acquire its pejorative modern meaning. At first it was replaced by *deaf mute*, but as oral education became more widespread, the term *mute* was also rejected as inaccurate.

A LANGUAGE SHARED BY HAND AND HEART

While Gallaudet's encounter with Sicard and sign language may have been an accident of history, evangelical educators soon found that sign language fit their mission like a glove and came to see it as foreordained. Gallaudet himself wrote after his European trip, "I rejoice in my disappointments at London and Edinburgh. God ordered them in his infinite wisdom and goodness—To him be all the glory of the success with which our undertaking has been crowned."

Teachers explained sign language in similar terms: it was "the natural language of the deaf," which in the parlance of the time meant that it was

Laura Redden Searing (1839–1923) was a graduate of the Missouri School for the Deaf. She began a fifty-year career as a journalist, poet, and author in 1859 under the name "Howard Glyndon." (Courtesy of Judy Yaeger Jones; Gallaudet University Archives, Washington, DC.)

"Signs are the natural language of the mute. Writing may be used in his intercourse with others, but when conversing with those who are, like himself, deprived of hearing and speech, you will always find that he prefers signs to every other mode of intercourse. . . . Pantomime is the language Nature has provided for the mute, and he should never be discouraged in making signs. Teach him to articulate if you can, make him a good writer if you will, but you will find, if he has his choice, signs will always be the medium of his intercourse with others. . . . Signs, when used by one well versed in them, can be made to convey the most subtle and abstract ideas. They are a language built up like any other, and those who would acquire it perfectly and thoroughly must make it a life-study. . . . Do not think that our lot is all dark; that because the many glad sounds of earth fall not upon our ears, and no words of affection or endearment pass our lips, all sources of happiness are closed to us. Oh! no, no. Our God is a tender and merciful Father, and well has he provided for his 'silent ones.'"

Laura Redden Searing,
A Few Words about the Deaf and Dumb, *1858*

the *intended* language of the deaf. The phrase "God is the author of nature" was a cornerstone of nineteenth-century Protestantism: nature was God's will made physical and its visible expression. To risk contravening nature was generally agreed to be a dangerous course. The difficulty, of course, lay in divining nature's path.

In this instance, educators took as a clear signpost the fact that deaf children, without any prompting, *naturally* resorted to gesture to communicate with their families and others around them. Furthermore, untutored Deaf communities in the great cities of Europe had developed their own sign languages without any outside intervention. Gallaudet concluded that this "singular language which nature has taught" deaf people was an example of the "great principle of *compensation*" by which "the God of nature" eased the afflictions of his creatures; in other words, "the wind has been kindly tempered to the shorn lamb." Deaf people themselves commonly referred to their language as the "natural language of the deaf" at one moment, and the "gift of God" the next. The meaning for most nineteenth-century Americans was the same.

A common perception of sign language, then and now, is that it is more emotionally expressive

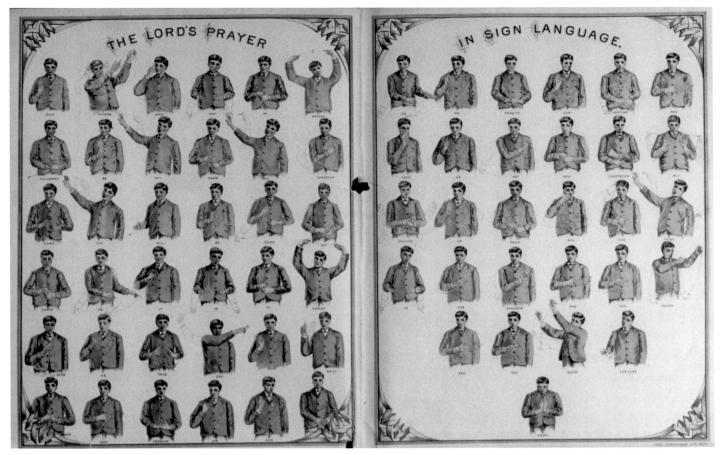

Lithographs were used to teach prayers that were often signed in unison. (Gallaudet University Archives, Washington, DC.)

ordained minister, believed that "no other object than the salvation of souls of the pupils can be named as of the highest moment; and to accomplish this object a very solemn responsibility is devolved upon all who are concerned in the affairs of the Asylum." While this was not the exclusive motivation for all the teachers, many explicitly equated their work with that of the missionary. One wrote that the uneducated deaf people of America may "as well have been born in benighted Asia, as in this land of light;" they represented "a community of heathen at our very doors." The teachers avowed that to teach deaf students "the gospel of Christ, and by it to save their souls, is our great duty." Just as other missionaries learned Native American or African languages and went to preach among the unconverted, early teachers of the deaf learned sign language so that they might bring light into the darkness.

"A cup of consolation for the deaf and dumb who heretofore had been wandering in a moral desert, from the same fountain the Hindoo, the African, and the savage are beginning to draw the water of eternal life."

Thomas Hopkins Gallaudet

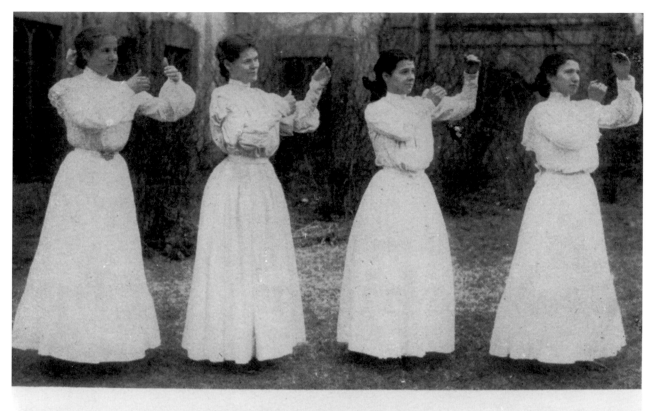

"NEARER, MY GOD, TO THEE."

Public performances of signed songs, particularly religious songs, were popular. Here, students from the Michigan School for the Deaf sign the hymn "Nearer My God to Thee." (Gallaudet University Archives, Washington, DC.)

FROM ASYLUM TO SCHOOL

Early schools for deaf students usually included the words *asylum* or *institution for the deaf and dumb* in their names. Later in the nineteenth century, they began referring to themselves as *schools* to make clear their purely educational function. Similarly, the term *dumb*, which appeared in many early school names and meant simply nonspeaking, was dropped as it began to acquire its pejorative modern meaning. At first it was replaced by *deaf mute*, but as oral education became more widespread, the term *mute* was also rejected as inaccurate.

A LANGUAGE SHARED BY HAND AND HEART

While Gallaudet's encounter with Sicard and sign language may have been an accident of history, evangelical educators soon found that sign language fit their mission like a glove and came to see it as foreordained. Gallaudet himself wrote after his European trip, "I rejoice in my disappointments at London and Edinburgh. God ordered them in his infinite wisdom and goodness—To him be all the glory of the success with which our undertaking has been crowned."

Teachers explained sign language in similar terms: it was "the natural language of the deaf," which in the parlance of the time meant that it was

"Signs are the natural language of the mute. Writing may be used in his intercourse with others, but when conversing with those who are, like himself, deprived of hearing and speech, you will always find that he prefers signs to every other mode of intercourse. . . . Pantomime is the language Nature has provided for the mute, and he should never be discouraged in making signs. Teach him to articulate if you can, make him a good writer if you will, but you will find, if he has his choice, signs will always be the medium of his intercourse with others. . . . Signs, when used by one well versed in them, can be made to convey the most subtle and abstract ideas. They are a language built up like any other, and those who would acquire it perfectly and thoroughly must make it a life-study. . . . Do not think that our lot is all dark; that because the many glad sounds of earth fall not upon our ears, and no words of affection or endearment pass our lips, all sources of happiness are closed to us. Oh! no, no. Our God is a tender and merciful Father, and well has he provided for his 'silent ones.'"

Laura Redden Searing,
A Few Words about the Deaf and Dumb, *1858*

Laura Redden Searing (1839–1923) was a graduate of the Missouri School for the Deaf. She began a fifty-year career as a journalist, poet, and author in 1859 under the name "Howard Glyndon." (Courtesy of Judy Yaeger Jones; Gallaudet University Archives, Washington, DC.)

the *intended* language of the deaf. The phrase "God is the author of nature" was a cornerstone of nineteenth-century Protestantism: nature was God's will made physical and its visible expression. To risk contravening nature was generally agreed to be a dangerous course. The difficulty, of course, lay in divining nature's path.

In this instance, educators took as a clear signpost the fact that deaf children, without any prompting, *naturally* resorted to gesture to communicate with their families and others around them. Furthermore, untutored Deaf communities in the great cities of Europe had developed their own sign

languages without any outside intervention. Gallaudet concluded that this "singular language which nature has taught" deaf people was an example of the "great principle of *compensation*" by which "the God of nature" eased the afflictions of his creatures; in other words, "the wind has been kindly tempered to the shorn lamb." Deaf people themselves commonly referred to their language as the "natural language of the deaf" at one moment, and the "gift of God" the next. The meaning for most nineteenth-century Americans was the same.

A common perception of sign language, then and now, is that it is more emotionally expressive

than spoken language. An oft-stated corollary is that it expresses abstraction less well, but there is no evidence for either view. Both seem to spring from an unexamined assumption that because sign language appears to be more *of the body* than speech, it is more emotional and less intellectual. In later years this prejudice was often used to oppose the use of sign language in education, but for the early teachers of the deaf, the supposedly emotional nature of sign language was seen as a positive benefit rather than a drawback. Their enthusiasm for sign language was in good part a reflection of a culture that valued depth of feeling and sincerity of emotion.

Evangelicals considered the emotions to be a crucial component of religious experience and conversion. Moreover, they believed reason and intellect were too feeble to restrain the dangerous weaknesses and desires to which humans were prone. In the eighteenth century, traditional Calvinists condemned "New Light" evangelicals for immoderate displays of emotion. As one disapproving observer of an evangelical preacher wrote, "He began in a low and moderate Strain . . . but towards the Close of the Sermon . . . he began to raise his Voice, and to use many extravagant Gestures." By the mid-nineteenth century this style of preaching had become common.

Most teachers in the schools for the deaf shared these values. Gallaudet, for example, believed that while abstract knowledge was important, it was not the primary goal of education. Rather, he wrote, "the heart is the principal thing which we must aim to reach" in order to save the souls of the deaf, and "the heart claims as its peculiar and appropriate language that of the eye and countenance, of the attitudes, movements, and gestures of the body." For Harvey Peet, head of the New York school, it was above all else the "emotions which make man superior to the brute creation." Lucius Woodruff of the American Asylum agreed, insisting that "the heart is the noblest part of human nature, giving direction and imparting energy to the other faculties . . . all education should begin here."

CHAPTER THREE

The Formation
of a Deaf Community

A HOME AWAY FROM HOME

The residential school was the crucible in which American Deaf culture was forged. Students came to these schools from scattered farms and small towns. They slept in common dormitory rooms, ate at common tables, attended classes, learned about the world, and came of age together. The residential schools, like boarding schools everywhere, created a fairly regimented life for the students. Thomas Tillinghast, a student at the Virginia School for the Deaf, described his daily routine to his parents as follows: the day began with a breakfast of bread, butter, and coffee at six in the morning, followed by prayers at seven-thirty and then classes until one o'clock. The students ate a large lunch until two, when they had instruction in such crafts as bookbinding, cabinetmaking, and shoemaking. A brief recess preceded supper at five-thirty, followed by a half hour of prayers, then free time until bed at nine for the younger students, ten o'clock for the older. The entire day—the lessons, the mealtime conversations, the horseplay, the fights and the prayers—was conducted in a visual language. For many students who came from hearing families, this was a welcomed change.

◀ Deaf children often stayed at a residential school for extended periods of time. Many took the train to school and recall having a note pinned to their clothes asking the conductor to put them off at the correct stop. Here, Anna Schuman (*far right*) leaves home in Little Falls, Minnesota, in 1916 to catch a train for the Minnesota School for the Deaf in Faribault. (Minnesota State Academy for the Deaf, Faribault.)

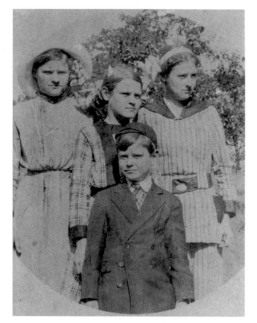

Not all deaf children left home alone to attend school. This 1913 photograph shows Elva, Ruth, Nora, and Matthew Nanney, who attended the Oklahoma School for the Deaf. Children from deaf families who already knew sign language usually had an understanding of the school because their parents could communicate where they were going and why. (Courtesy of Richard Reed, from the collection of Ruth (Nanney) Reed.)

Residential schools were complete communities in themselves, and life within them reinforced the cohesiveness of the developing Deaf community. Students passed their days immersed in a language addressed to the eye and among people, hearing and deaf, who valued it. They formed deep and long-lasting attachments to their schools, their teachers, their classmates, and, most of all, to a way of life they created together and shared. When students came of age and graduated, some remained to work as dormitory, kitchen, or maintenance staff. The brightest among them stayed on to take "high

▼ Dormitory life was often crowded for deaf children. Dozens of boys or girls might sleep in the same room with little space for any personal items. These boys attended the Alabama School for the Deaf, ca. 1918. (Alabama School for the Deaf, Talladega.)

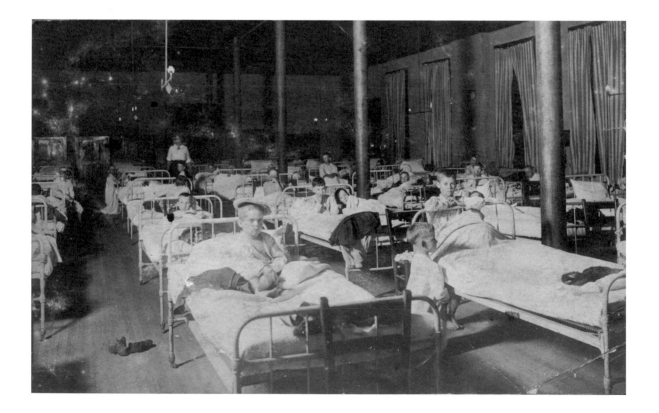

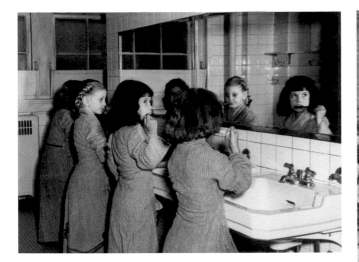

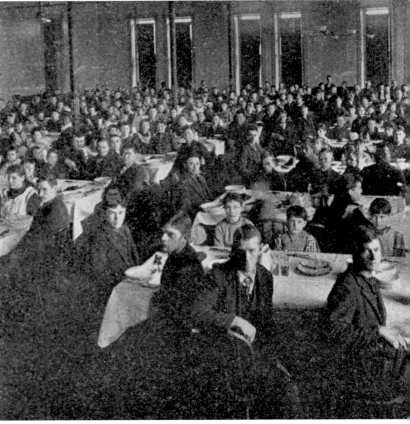

▲ Life was regimented for children attending Deaf residential schools, as it was for all children in boarding schools. The children woke together, prepared for the day, and moved as a group. These girls, shown brushing their teeth, were in the primary program at the Missouri School for the Deaf. (Gallaudet University Archives, Washington, DC.)

▶ Dining halls, such as this one at the Kansas School for the Deaf, had to serve hundreds of children three times a day. Students helped to serve meals and often assisted with meal preparation. (Gallaudet University Archives, Washington, DC; from S. Tefft Walker, "The Kansas Institution," in *Histories of American Schools for the Deaf* 1817–1893, ed. Edward Allen Fay, (Washington, DC: Volta Bureau, 1893).

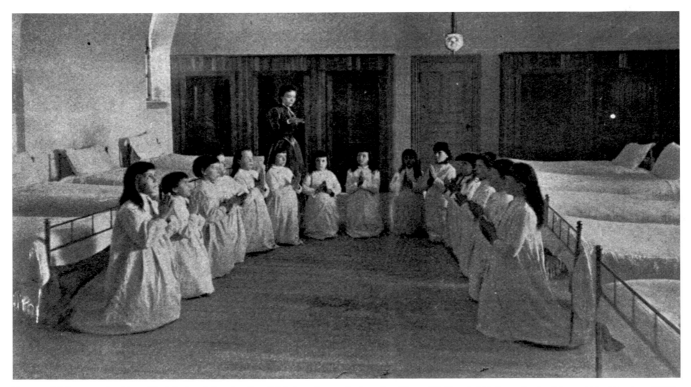

Young children at the New York School for the Deaf (Malone) pray before bedtime. (Gallaudet University Archives, Washington, DC.)

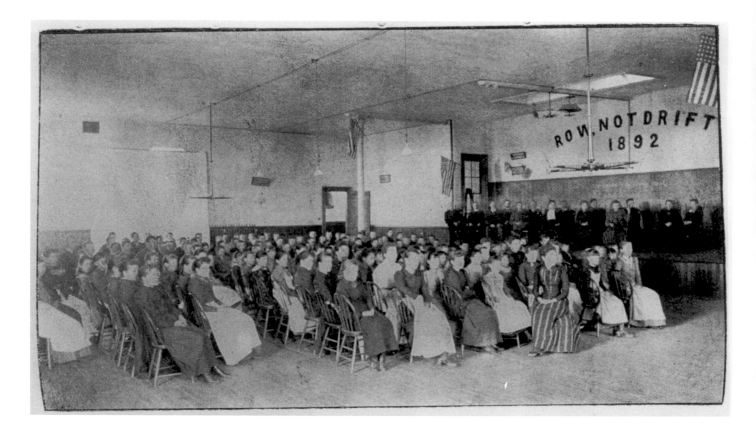

classes" and often became teachers themselves. By the 1860s, deaf teachers made up nearly 40 percent of the total. Since most schools were built on the edge or outside of town, deaf children and adults had little contact with the hearing world.

"The coach stopped at the front door and we emerged therefrom. A few small boys came around with curious looks, the nearest, with bright eager face and quick eyes scanned me from head to foot, . . . motioned to the next nearest boy, then to me, and said I was *a new pupil*. I did not understand then, but guessed and remembered these simple signs. We entered the hall, and in a few minutes Mr. Gallaudet, the Principal, came . . . It was all new to me . . . the innumerable motions of hands and arms. . . . I was among strangers but knew I was at home."

Edmund Booth, Autobiography, *1881*

▲ Students were required to attend regular chapel services where, among other things, they were taught to "Row, Not Drift." (Gallaudet University Archives, Washington, DC.)

▶ Students attending the Kentucky School for the Deaf participated in the Christian Endeavor Society. Here they show their awards for good deeds. (Kentucky School for the Deaf, Danville.)

▶ Many of the students lived far from their homes. When they became sick, they were sent to the school infirmary. Here, three boys from the Alabama School for the Deaf receive care from nurses, ca. 1910–1920. The boy on the left has his head propped up by a chair, probably to help him breathe. (Alabama School for the Deaf, Talledega.)

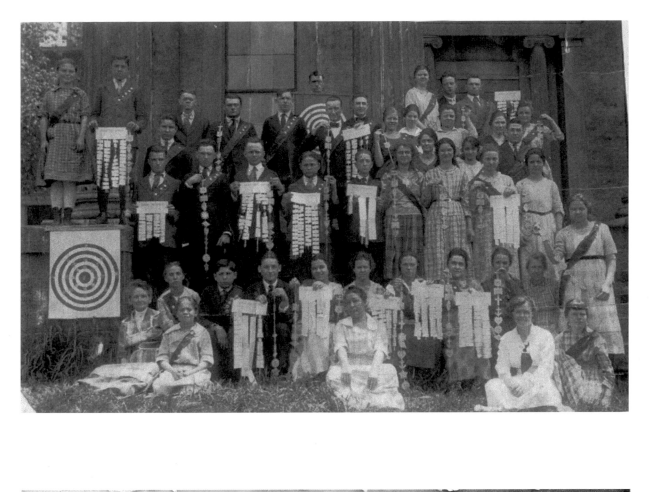

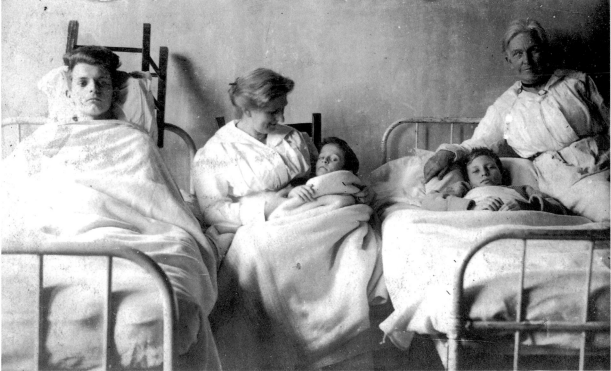

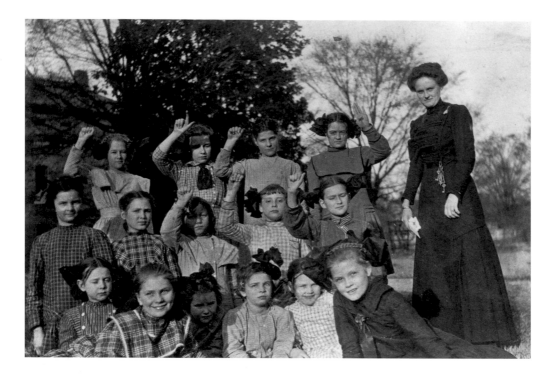

▲ Girls from the Alabama School for the Deaf fingerspell A-L-A-B-A-M-A. (Gallaudet University Archives, Washington, DC; gift of Robert Werdig, Jr.)

◀ In this photograph from 1910, students from the North Carolina School for the Deaf show each other's name signs. (Gallaudet University Archives, Washington, DC; from the album of Jennie Jones Werdig, gift of Robert Werdig, Jr.)

Thousands of young deaf people eventually came to these schools to spend years living and studying together. More than a new language was formed; from the countless daily interactions and negotiations of life in a small, intimate community, a new culture emerged. Deepened and enriched by each passing generation, American Deaf culture over time generated the creative outpouring typical of human communities everywhere—folklore, poetry, storytelling, theater, and oratory; as well as games, jokes, naming customs, rituals of romance, and rules of etiquette and proper conduct—all enacted in a language of gesture and suited to a visual people.

AN EDUCATION

Deaf students, like hearing students in the expanding public school system, spent most of their instructional time in reading, writing, and arithmetic, but as they advanced they also studied geography, science, art, and history. Bible study and chapel attendance were usually required, but, indeed, reli-

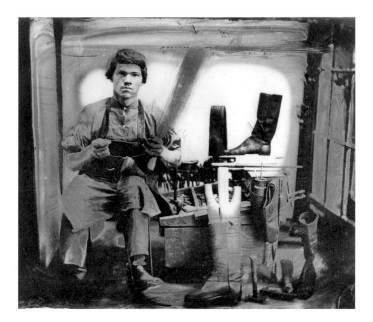

◀ Shoemaker Leonard Bartlett, who attended the American School for the Deaf, is seen in this early (1850–1865) daguerreotype print. Shoemaking was taught in many schools and was a common trade for deaf men. (The Connecticut Historical Society Museum, Hartford, CT.)

▼ Students were often told to keep their hands together, and down, in class, as these first-year students from the North Dakota School for the Deaf demonstrate in a 1904 photograph. While some teachers arranged the chairs in a semi-circle so that children could see each other, others had their students sit in rows. (State Historical Society of North Dakota C1293, Bismarck.)

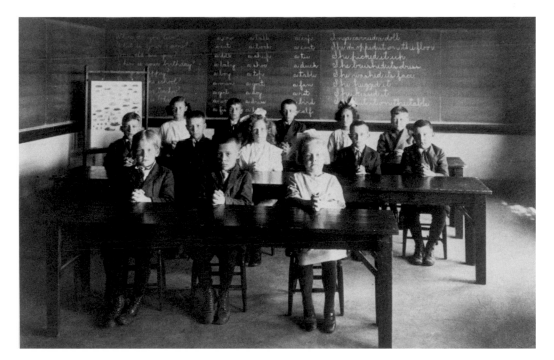

gious concepts suffused the entire curriculum. In their primary reader students might learn that "A is for Adam: In Adam's fall, we sinned all," while their geography text might explain that "as the earth is round, only half of it can be lighted at once. In order that both sides may be lighted, the Creator has caused the earth to rotate."

Teachers had to consider that their students might lack much of the mundane but essential knowledge that hearing children effortlessly picked up from overhearing casual conversation at home and wherever they went. For deaf students, the residential schools provided that kind of linguistically rich environment, where the unplanned curriculum

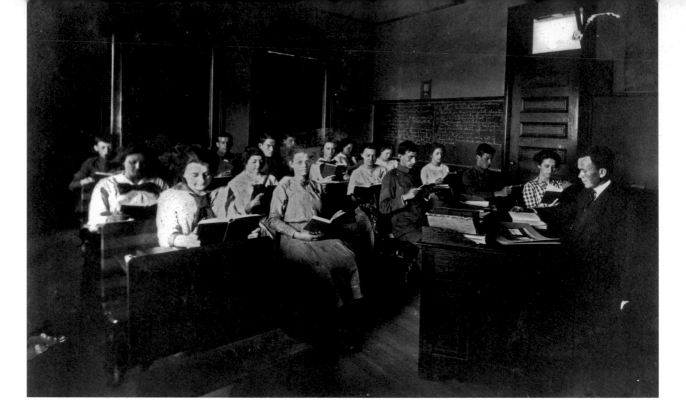

▲ Academic subjects such as reading, writing, science, and history were taught at residential schools for deaf students. This high school class is from the North Carolina School for the Deaf, ca.1915. (Gallaudet University Archives, Washington, DC; from the album of Jennie Jones Werdig, gift of Robert Werdig, Jr.)

▼ In addition to core academic subjects, students at the Texas School for the Deaf could take painting, drawing, and china painting. (Gallaudet University Archives, Washington, DC; from the collection of Rev. Robert and Mrs. Estelle Caldwell Fletcher.)

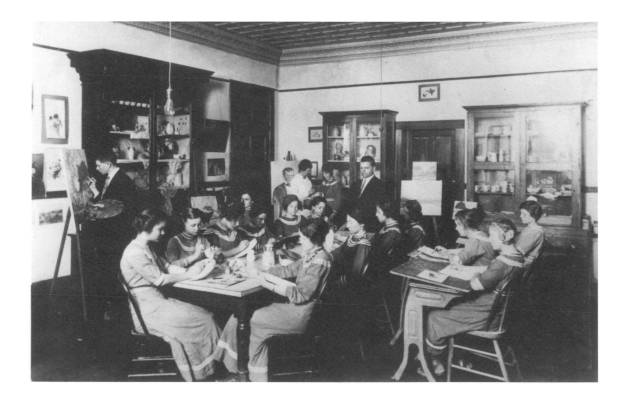

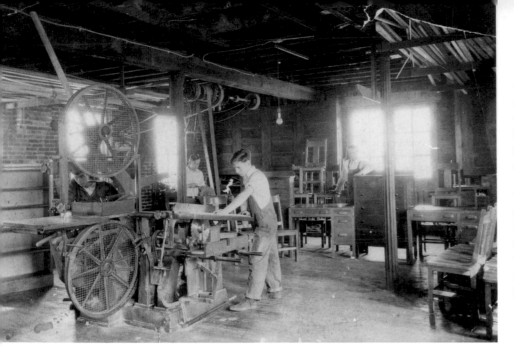

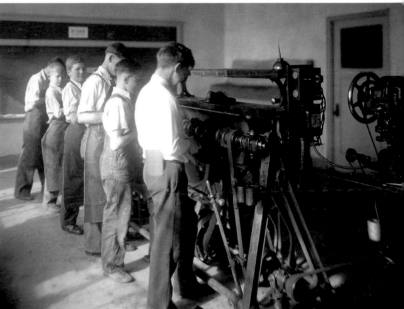

◀ Leather and woodworking were common shop classes offered to deaf boys. Each school had a limited number of vocational programs. (Gallaudet University Archives, Washington, DC.)

▼ Shoemaking and repair offered steady work for a skilled cobbler. Many graduates opened their own shops. These students attended the North Dakota School for the Deaf in the 1930s. (North Dakota School for the Deaf, Devils Lake.)

of everyday life became accessible to them. Teachers made a point of discussing local and national news with their classes, knowing that for many of their students, especially the younger ones, they were the primary source of information about world events. Sports, literary clubs, debating societies, and theatrical performances rounded out the students' education. To outsiders, it seemed as if deaf children were sent away to be confined in gated institutions, but for many deaf children, going into the residential school meant coming into the world.

"It was my good fortune during my school days at Hartford to be associated in close companionship with a number of remarkably intelligent young men. No logic could convince me that my association with these young men was not of greater benefit to me . . . than the sum of all other influences. . . . Among these young men there was a constant 'fusillade of discussion'; there was scarcely any subject pertaining to 'heaven above, the earth beneath, or the water under the earth,' that did not contribute material for disputation. Not unfrequently these discussions encroached upon the time that should have been given to their lessons, but it is undeniable that the mental stimulus and habits of independent study and investigation so acquired were as valuable to them as the grist of their daily tasks."

George Wing, 1886

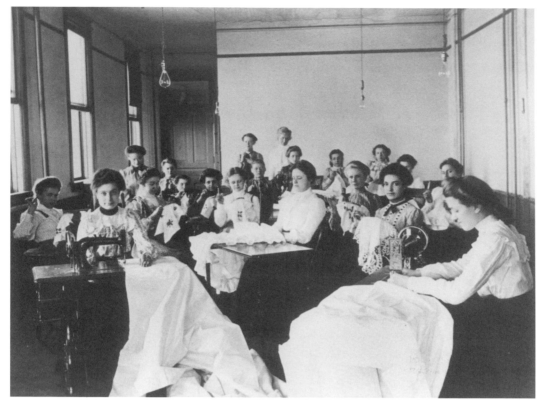

Sewing and needlework were considered important skills for girls. Students from the North Dakota School for the Deaf demonstrate the variety of sewing skills they have learned. In addition to sewing their own clothes, girls were often responsible for darning socks and mending clothes for boys and younger children at the school. Older girls also had ironing duties. (State Historical Society of North Dakota 0258-14, Bismarck.)

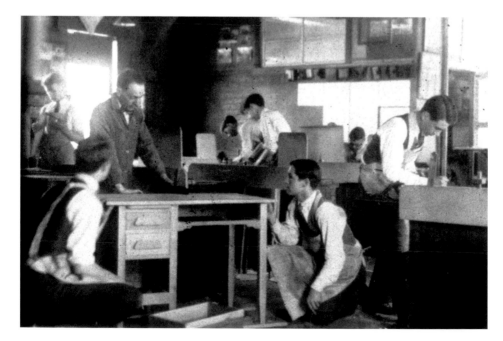

Shop classes were offered at both signing and oral schools for deaf children. These students at the Clarke School for the Deaf were taught using only oral methods, but the vocational skills they learned mirrored those taught at schools that used sign language. (Clarke School for the Deaf—Center for Oral Education, Northampton, MA.)

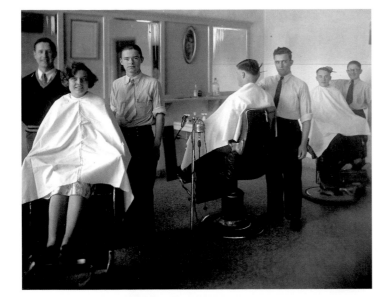

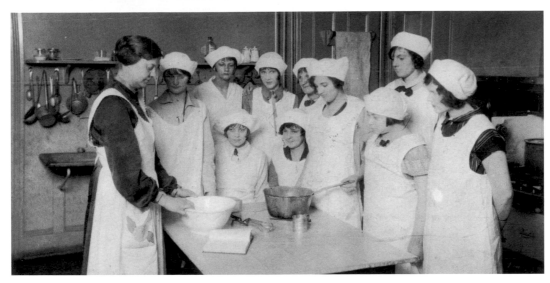

◀ The barbershop training offered at the North Dakota School for the Deaf allowed students to learn a trade and also provided a needed service on campus. (North Dakota School for the Deaf, Devils Lake.)

▼ Nutrition, menu planning, and shopping for food were among the skills taught in schools. These girls are learning how to follow a recipe in a cooking class at the Kendall School in Washington, DC, in 1925. (Gallaudet University Archives, Washington, DC.)

Residential schools for deaf students were pioneers in offering vocational training in addition to core academic courses. Like other Americans of the nineteenth and early twentieth centuries, the great majority of deaf people worked in manual trades, and their school training often gave them an advantage to offset employers' lack of knowledge about deaf people and prejudices against hiring deaf workers. Most schools offered courses for boys in printing, shoe-making, woodworking, farming, baking, and tailoring. Vocational training for girls was less extensive and offered fewer opportunities for advancement.

Predicated on the assumption that girls would either get married or take up some form of household labor, instruction for girls encompassed cooking, sewing, dressmaking, and other domestic endeavors thought appropriate to young ladies.

Printing became the preferred trade for many ambitious male students. It required skill, paid well, and was always in demand. By the end of the nineteenth century, and continuing through most of the twentieth century, almost all big-city newspapers had deaf printers on their staffs. Printing held high status in the Deaf community because the school

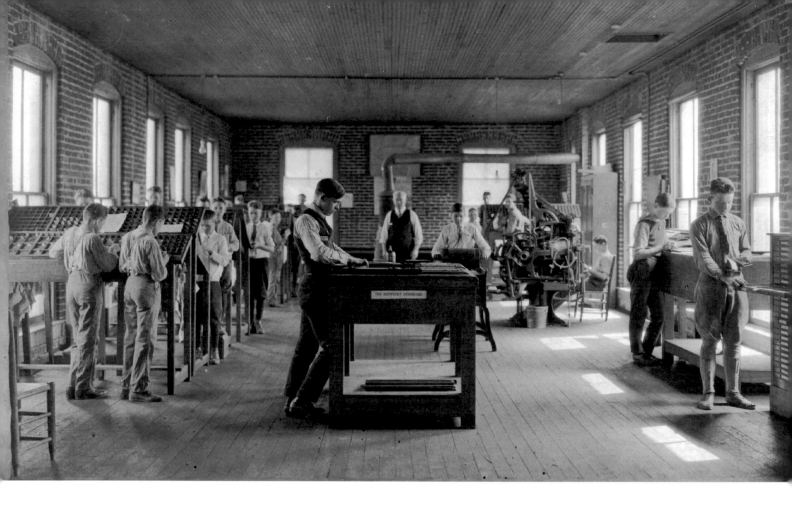

▲ These students are hand-setting type for the *Kentucky Standard*, their school newspaper. (Kentucky School for the Deaf, Danville.)

▼ Names of school newspapers changed over time. For example, the *Kentucky Deaf Mute* became the *Kentucky Standard*. Many schools removed references to "mute" or "silent" or "deaf." On this January 1886 edition, the caption under the illustration reads, "Speak, Hands, for Me." (Gallaudet University Archives, Washington, DC.)

printing instructor (nearly every residential school had a printing department) served as editor of the school newspaper. School newspapers were important organs of communication that helped to knit together the far-flung Deaf community, thus making their editors men of some influence and authority within the community. Many Deaf community leaders worked as printers at one time, including George Veditz, who later became president of the National Association of the Deaf, and Amos Draper who, after a brief career as a printer, became a professor of Latin and mathematics at Gallaudet College.

Teaching was the one profession open to most academically gifted deaf people. Residential schools did not pay well though, and deaf teachers, regardless of their gender, received about half the salary of male hearing teachers (but on a par with hearing female teachers). By the end of the nineteenth

century, a deaf teacher could expect to earn about $500 a year, while a skilled printer might earn three times as much. Nevertheless, teachers were accorded much respect within the Deaf community, and many of the brightest students aspired to the position.

In 1893 the Ohio School for the Deaf reported the following occupations for its graduates:

152	farmers	3	editors
62	type compositors	2	grocers
31	shoemakers	2	portrait painters
29	laborers	1	coal dealer
27	shoe factory workers	1	deputy recorder
25	teachers	1	horse dealer
17	bookbinders	1	postmaster
5	professional baseball players	1	railroad foreman
5	salesmen/peddlers	1	ship builder
3	school principals	1	saloon keeper

This issue of the *Oregon Outlook*, published by students at the Oregon School for the Deaf, is a contemporary publication (1988) depicting the production of the *SIGN*, which the school published several decades earlier. (Oregon School for the Deaf, Salem.)

Students learned printing skills and mastered new equipment as it became available. Here, Elmer Ivan Curtis is using a linotype machine at the Iowa School for the Deaf, ca.1924. (Gallaudet University Archives, Washington, DC; from the collection of Ivan and May Koehn Curtis.)

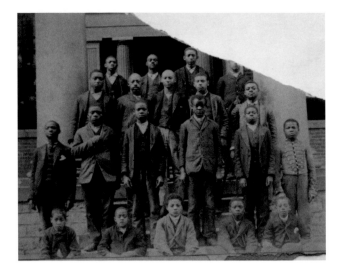

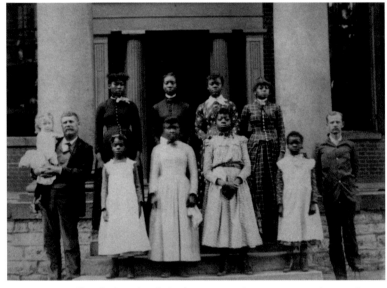

Southern schools had segregated programs, and sometimes campuses, for black and white students. Both of these photographs are from the Kentucky School for the Deaf, where students shared a campus but had separate classrooms and dormitories. (Kentucky School for the Deaf, Danville.)

A DIVIDING LINE

Prior to the Civil War, the Southern states provided no formal public education for African American deaf students. In 1868, North Carolina became the first to do so by creating a "Colored Department," and other Southern states soon followed its example. For more than a century, African American deaf children were educated either in separate buildings or on entirely separate campuses from those of the white students. Some of their schools were all-purpose institutions, such as the Oklahoma Industrial Institution for the Deaf, Blind, and Orphans of the Colored Race. The last remaining segregated program, the Louisiana School for the Colored Deaf and Blind in Baton Rouge, did not close its doors until 1978.

"The North Carolina School for the Blind and Deaf was for Black children. When I was there, it could handle about 300 children altogether. At that time, however, I think we had more deaf students than blind students. The school for White blind children was in town and the school for White deaf children was in western North Carolina. Although we had our own principal, our school and the school in town were under the same superintendent, George Lineberry, who was White. . . .

[In April] we started counting the weeks and days until the middle of May when we would go home. I couldn't wait to show off all the things I had learned to do: sign language, handicrafts, and rug weaving. . . . The last morning we had to strip our beds and turn the mattresses back. The dorm looked strange with all those beds in two long rows. It also looked lonely, and somehow I felt a little sad, for I had made friends and I'd miss them. . . .

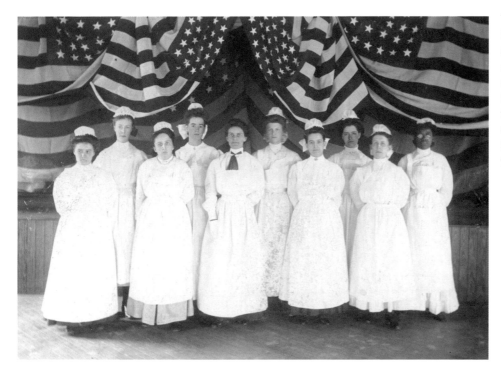

The American School for the Deaf had integrated classes as early as 1825. This image shows an integrated cooking class (ca. 1900), long before hearing, public schools taught black and white children together. (The American School for the Deaf, Hartford, CT.)

... About dark, we were loaded in cars and taken to the railway station, herded in, and parked on benches. Some White blind children were also in our group. . . .

. . . We then were herded out a door and down a dark and dirty-looking passageway and onto a cold railway car with hard seats."

Mary Herring Wright, Sounds Like Home: Growing up Black and Deaf in the South *(Washington, DC: Gallaudet University Press, 1999), 95, 106–107*

As in so much else about the Reconstruction period following the Civil War, there were moments when a different and better history seemed possible. In 1873, the Board of Commissioners of the South Carolina School for the Deaf, which had been appointed by the reformist majority elected to the state legislature after the enfranchisement of African Americans, sent the following instructions to the superintendent of the school:

First. Colored pupils must not only be admitted into the Institution on application, but an earnest and faithful effort must be made to induce such pupils to apply for admission.

Second. Such pupils, when admitted, must be domiciled in the same building, must eat at the same table, and be taught in the same classroom and by the same teachers, and must receive the same attention, care, and consideration as white pupils.

In response, the superintendent, officers, and teachers of the school promptly resigned, effectively shutting down the school. It did not reopen until 1879. By that time, segregationists had regained control of the legislature and the school was, as before, reserved for whites only. A few years later, the board again turned its attention to the needs of African American students. It directed that an abandoned "wooden building known as the old hotel situated near to the spring be set apart for the use and occupation of colored deaf and dumb and blind students."

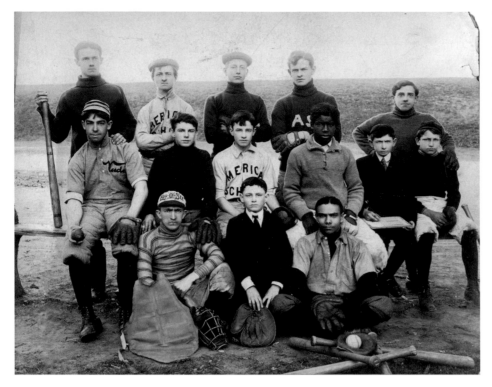

These students played on an integrated baseball team at the American School for the Deaf (ca. 1910). Many northern and western schools were integrated at the time. (The American School for the Deaf, Hartford, CT.)

"Just beyond the main building of the South Carolina School for the Deaf and the Blind, toward the edge of campus, there is a gently rising spot of land with low-hanging trees and a fence around it. It is the Cedar Springs Baptist Church cemetery . . . Behind the rows of family tombstones is a less adorned section, where instead of gently hanging trees, the land is open and dotted with short bushes. This is the African-American section of the cemetery, where there lie mostly river rocks and temporary funeral markers where the handwritten names of the deceased have faded . . . The two sides of the cemetery stand as a lingering reminder that for most of their early history, schools for deaf children in the South taught their white and African-American children separately."

Carol Padden and Tom Humphries,
Inside Deaf Culture *(Cambridge: Harvard University Press, 2005), 37–38*

The relatively small number of African American deaf students living in the North usually attended residential schools with white students. At a meeting of teachers of the deaf in 1882, the superintendent of the North Carolina school boasted that his was the "first state in establishing institutions for the colored race, although other states are falling into line." Philip Gillett, the superintendent at the Illinois school, stood up to point out, with heavy sarcasm, that "Illinois has had an institution for colored deaf-mutes for over thirty years. . . . We have not been able to make any special provision for them. What we provide for the whites, we think is good enough for the colored. They have always had admission to this institution on precisely the same basis and the same advantages that the whites have had."

The physical separation of the races in the South resulted in distinct white and black dialects of American Sign Language that persisted for many decades. During the 1920s and 1930s, when large numbers of

black Southerners migrated to the North, many more black deaf students enrolled in the (mostly) integrated Northern residential schools. When Southern schools for deaf children finally integrated in the latter decades of the twentieth century, the buildings and campuses set aside for African Americans were closed or incorporated into the schools for white students. Because residential and magnet schools in recent decades have tended to bring together black and white deaf students (more so than schools for hearing students), the separate dialects of ASL have largely, though not entirely, disappeared.

"From the very early days of the institution we have had colored pupils. . . . We had separate sleeping rooms and separate tables for them but placed them with the white pupils in the classrooms. . . . On a good many occasions we had complaints from the parents of white children and protests against the mixture of the races in our school. Some difficulties also arose, growing out of the treatment of the colored by the white. . . . Senator Cockrell rendered very important aid in securing the necessary action of Congress authorizing the transfer of the colored deaf children of the District to the Maryland School for Colored Deaf-Mutes in Baltimore.
 . . . The transfer was successfully made in September 1905."
Edward Miner Gallaudet, History of the College for the Deaf, 1857–1907 *(Washington, DC: Gallaudet University Press, 1983), 201–202*

Few records remain today of the Southern African American schools for the deaf. Some did not keep extensive records to begin with, while others were destroyed when segregation came to an end and the schools closed. The few reports that survive speak often of needing more funding for buildings, instruc-tional materials, and teachers. Class sizes appear to have been consistently much larger than in the white schools and educational necessities in short supply. Beyond such generalities, however, we know little about the students and their teachers, what they thought of their schools, or how they spent their days.

AN ASSOCIATION

When French writer and politician Alexis de Tocqueville visited the United States in the 1830s, he was impressed by the American fondness for forming civic organizations: "Americans of all ages, all stations in life, and all types of disposition are forever forming associations," he observed in *Democracy in America.* "There are not only commercial and industrial associations in which all take part, but others of a thousand different types—religious, moral, serious, futile, very general and very limited, immensely large and very minute." Deaf Americans were no exception to this American proclivity. Indeed, like other ethnic groups, they have been extremely active in forming and participating in various organizations. Local clubs that offered a focus and physical space for the community to come together had the most immediate impact on the lives of deaf people. Associations at the state, regional, and national levels have provided deaf people with platforms for political action, means of promoting and protecting their interests, and networks for keeping in touch with others at a distance.

The first regional organization, the New England Gallaudet Association of Deaf-Mutes, named in honor of Thomas Hopkins Gallaudet, was formed in 1854. It began when alumni from the Hartford school met to discuss the possibility of forming a national organization of deaf people. They decided that this idea was impractical, given the great distances involved. Travel was still slow and difficult; railroads did not yet link most of the country. They decided,

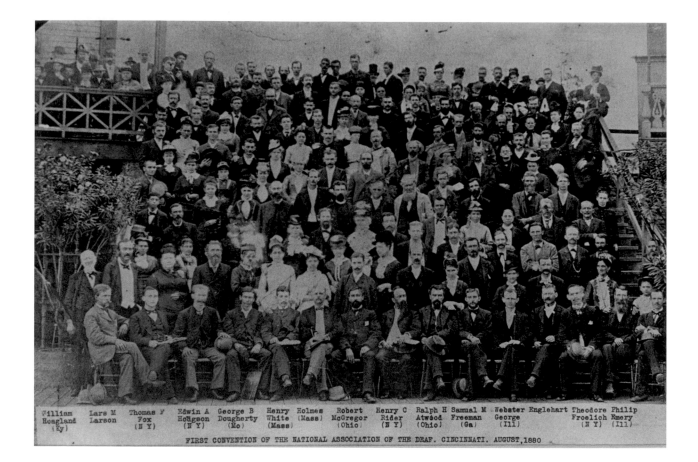

William Hoagland (Ky) Lars M Larson Thomas F Fox (N Y) Edwin A Hodgson (N Y) George B Dougherty (Mo) Henry White (Mass) Holmes (Mass) Robert McGregor (Ohio) Henry C Rider (N Y) Ralph H Atwood (Ohio) Samuel M Freeman (Ga) Webster George (Ill) Englehart Theodore Froelich (N Y) Philip Emery (Ill)

FIRST CONVENTION OF THE NATIONAL ASSOCIATION OF THE DEAF. CINCINNATI. AUGUST, 1880

however, that they could manage a regional association, and so they drafted a constitution for an organization "to promote the intellectual, social, moral, temporal and spiritual welfare of our mute community." The constitution exemplified the dual identity of deaf people. It used the term *mutes* to talk about its members, thereby emphasizing that they were people who signed rather than spoke, but it specified that people who were "only deaf or who have never been in any institution for deaf mutes" were also welcome to join. Hearing people could not become members, but they did attend and participate in meetings, which were interpreted for the nonsigners.

Within a few years, deaf people in other states had formed their own associations. Mounting concern in the Deaf community over the state of deaf education, especially the increasing vitriol against

▲ The first convention of the National Association of the Deaf was held in Cincinnati, Ohio, in 1880. (National Association of the Deaf, Silver Spring, MD.)

▶ Teachers of deaf students also organized and formed national organizations. This convention of administrators and instructors of the deaf met in Columbus, Ohio, in 1878. (Gallaudet University Archives, Washington, DC.)

sign language in the schools, the poor condition of vocational education, and public prejudices and misconceptions concerning deafness, prompted Deaf leaders to create a national association that would be better able to address such issues. The National Association of the Deaf held its first meeting in 1880 in Cincinnati, with attendees from twenty-two states. "The object of this Convention," wrote

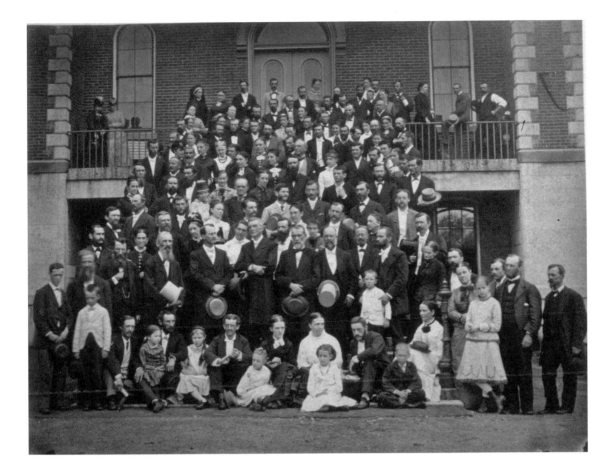

Theodore Froehlich, a representative from the Manhattan Literary Association of Deaf-Mutes, was "to bring the deaf-mutes of the different sections of the United States in close contact and to deliberate on the needs of deaf-mutes as a class by themselves." The occasion marks as well as any the realization of an American Deaf community.

"Like their peers in the hearing world, white deaf leaders sanctioned segregation and blocked deaf African Americans from their national organizations. In civic life, they left unchallenged a system that denied most southern African American deaf children an education and ensured their economic marginalization as deaf adults. . . . Thus, two parallel communities developed with little interaction between them: the first, comprised primarily of whites, has been described by hearing society—as well as by most deaf citizens—as 'the deaf community'; the second, for the most part unrecognized even today, was composed of deaf African American women, men, and children."

Robert M. Buchanan, Illusions of Equality: Deaf Americans in School and Factory, 1850–1950 *(Washington, DC: Gallaudet University Press, 1999), 17*

A SILENT PRESS

Like other American ethnic communities, deaf people established periodicals to report local and national news of interest to their community. While most of these publications were affiliated with

In this 1889 issue of the *Deaf-Mutes Journal*, its well-known and influential editor, E. A. Hodgson, is seen bursting through the text. (Gallaudet University Archives, Washington, DC.)

"When Johann Gutenberg invented movable type in the 1400s, he did not realize what a favor he was doing deaf people. Printing became a leading trade and an excellent occupation for deaf people in the United States. This development led naturally to the publication of periodicals by and for deaf people."

Jack R. Gannon, Gallaudet Encyclopedia of Deafness and Deaf People *(New York: McGraw Hill, 1987), vol. 2, 278*

The first independent newspaper exclusively aimed at the Deaf community, the *Gallaudet Guide and Deaf-Mute's Companion*, was established in 1860 in Boston by William Chamberlain. It was the official organ of the New England Gallaudet Association of the Deaf, but it lasted for only five years. Boston was home to another independent paper, the *Deaf-Mute Gazette*, which started in 1867 and continued for several decades. The *Silent World*, published in Washington, D.C., became the first literary magazine in the Deaf press in 1871. In 1874, Henry Rider began publishing the *Deaf-Mute's Journal*, which grew out of a one-page supplement to the *Mexico* (New York) *Independent* and became the first weekly newspaper of an increasingly interconnected national Deaf community. It lasted until 1951.

These independent newspapers were far outnumbered by the papers produced in the residential school print shops. The school papers served several purposes: they encouraged literary expression among students, informed the students' families about school matters, maintained ties with school patrons and alumni, and provided students with practical experience in printing. These papers soon acquired significance well beyond what the schools had first intended, however; they helped to forge connections among students, faculty, alumni, and local deaf people associated with the school, providing a forum for the exchange of ideas and information. Their

schools, some were independent operations, usually run on a shoe-string budget and often short-lived. Levi Backus, a graduate of the American School who had studied under Laurent Clerc, started the first known deaf periodical in 1837. Backus bought a local newspaper, the *Canajoharie Radii,* in upstate New York, where he taught at a small school for deaf students. He continued to publish it as the town's general interest newspaper, but he added a section containing news of interest to the Deaf community and converted the paper's banner, *The Radii,* to printed fingerspelling. The state legislature appropriated money to mail the newspaper to deaf people around the state.

influence widened when schools began to share their papers via the mail and place them in their school libraries, thus creating an informal network (fondly known as the "Little Paper Family") that nurtured a growing sense of unity within the widely scattered Deaf community.

The first school newspaper was the monthly *Deaf Mute*, begun in 1849 at the North Carolina Institution for the Deaf, Dumb, and Blind. It took some time for school papers to catch on, but they soon proliferated. The *Mute's Chronicle* (Ohio) began in 1868, the *Deaf-Mute Advance* (Illinois) in 1870, the Kentucky *Deaf-Mute* and the Michigan *Deaf-Mute Mirror* in 1873, and papers at the Colorado, Virginia, and Nebraska schools in 1874. The Little Paper Family grew rapidly after that, with nearly fifty school papers being published by the end of the century, more than thirty of them weeklies and at least three published daily. The best of them acquired nationwide reputations and subscription lists, becoming sources for both local and national news.

One paper achieved international status. The New Jersey School for the Deaf newspaper was called the *Deaf-Mute Times* when a new printing instructor and editor, George S. Porter, took over in 1891. Porter renamed it the *Silent Worker* and transformed it from a small, four-page tabloid into a professional, well-written, often visually stunning magazine. The paper included features about Deaf community leaders, histories of schools for the deaf, travelogues, national and international news, as well as an industrial and a gardening column. Porter developed a network of deaf corre-

The October 1928 issue of the *Silent Worker* focuses on "dactylology." The manual alphabet and the print alphabet surround the page and the etching shows women holding hands and encircling a hand. (Gallaudet University Archives, Washington, DC.)

spondents around the United States and in Europe, Latin America, and several Asian countries who contributed articles on Deaf communities around the globe.

WOULD NOT KNOW WHAT TO DO WITHOUT IT
I have received every copy of the [*Silent*] *Worker* up to January, and I hope that you can find an extra January number to send me, in spite of Mr. Meagher's prediction that they would all be snapped up. I had no intention of letting my sub- scription lapse, I would not know what to do without the SILENT WORKER—it's the one connecting link with the "rest of the world," (the deaf world.) The only fault I can find with your magazine is that there is not enough of it!

Muriel Bishop, Atlanta, Ga.

A DEAF REPUBLIC

During the years 1856 to 1858, a remarkable exchange of letters took place in the pages of the *American Annals of the Deaf* over a proposal to create a separate Deaf republic. The *Annals*, a professional journal published for teachers of deaf students, often contained articles by deaf teachers and other well-educated deaf people. The debate began when James J. Flournoy (or "J.J.," as he signed himself), a deaf Georgian, wrote and circulated a pamphlet in the Deaf community proposing that a new state be created exclusively for the deaf in one of the western territories. He then asked William Turner, a hearing man and one of Flournoy's former instructors at the American School, for his opinion of this proposal. Turner's letter to Flournoy was printed in the *Annals* along with Flournoy's rebuttal. This subject provoked fourteen letters in all, four of them from Flournoy, as well as a long commentary by the editors of the journal, which extended over three issues.

Turner responded that while the idea was "beautiful in theory," it could not succeed for several reasons. For one, deaf people usually had hearing children; therefore, the deaf residents would either have to send their children away or eventually be outnumbered by their hearing offspring. For another, the Deaf community was interwoven into the larger society, and Turner doubted that most deaf people would wish to sever their ties with hearing friends and family. While Flournoy had answers for each objection, what angered him most was Turner's suggestion that deaf people ought to accept the subordinate position that their natural limitations made inevitable: "You would not send a deaf and dumb man to Congress or to the Legislature of a State," Turner argued, "not for the reason that he was deficient in intelligence and education, but because his want of hearing and speech unfits him for the place."

The debate ostensibly concerned political autonomy for the American Deaf community, but it was

"Flournoy suggested that he and his Deaf peers create their own state in the western territories: a 'Deaf-Mute Republic.' As he wrote, 'It is a political independence, a STATE SOVEREIGNTY, at which I aim, for the benefit of an unfortunate downtrodden class.' Only by this measure could Deaf people 'attain the dignity and honor of Human Nature.' He concluded that a separate state was the 'manifest destiny of our people.'

In such a state, Deaf people could manage their own affairs, elect their own leaders, and live in a state that embraced American Sign Language as its primary language: 'We will have a small republic of our own, under our own sovereignty, and independent of all hearing interference.'"

Hannah Joyner, From Pity to Pride: Growing up Deaf in the Old South *(Washington, DC: Gallaudet University Press, 2004), 114*

at least as much a debate over the meaning of deafness. Did deaf people receive fair treatment from hearing people, and were whatever troubles deaf people experienced therefore inherent in deafness itself? Edmund Booth, a successful deaf newspaper owner and editor in Anamosa, Iowa, thought so. At a meeting of the New England Gallaudet Association, the elderly Laurent Clerc dismissed the idea that deaf people were oppressed by the hearing. Flournoy insisted that deaf people "encounter insurmountable prejudice where we would assert equality," and P. H. Confer, an Indiana farmer, agreed, writing that "many people look upon a deaf-mute as if he were a fool, because he can not talk. . . . If they were by themselves, they could be happy."

Most of the letter writers opposed Flournoy's idea, but their views cannot be said to have been representative because *Annals* readers tended to be

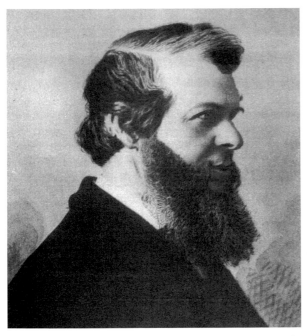

Edmund Booth was a successful newspaper owner and editor in Anamosa, Iowa. He opposed Flournoy's plan for a deaf state. (Courtesy of the Haggin Museum, Stockton, CA.)

"The old cry about the incapacity of men's minds from physical disabilities, I think it were time, now in this intelligent age, to *explode*! You asked, how could a deaf man legislate and govern among the hearing, any more than a blind man lead an army? . . . Have you ever heard how Muley Moloch had himself borne in a litter, when lamed by wounds, to the head of his legion, and how he vanquished the foe? So much for a *lame* man. Then, as for a *blind* one, such a one as the beggared Belisarius of declining Rome or Byzantium; was such a man of no military moment because sightless? . . . We do not claim *all* offices, nor to do *every* thing. But we do attest that we are capable of many of which the prejudice, and sometimes even malignance of our hearing brethren deprive us!!...

Advocating, therefore, a formation out West, of a deaf State, I wish to persevere in urging a

measure by which alone our class of people can attain to the dignity and honor of Human Nature."
John Jacob Flournoy, "Mr. Flournoy's Plan for a Deaf-Mute Commonwealth," American Annals of the Deaf *(1858); reprinted in Christopher Krentz, ed.,* A Mighty Change: An Anthology of Deaf American Writing, 1816–1864, *(Gallaudet University Press, 2000), 166–67*

better educated and more successful than the average citizen. Flournoy was not alone in wishing for a deaf state. Clerc and Booth had both entertained similar, if less ambitious, ideas earlier in their lives. Similar proposals have circulated in the Deaf community time and again, not just in the United States but in Britain, France, and Canada as well, expressing what Henry Rider, president of the Empire State Association (New York), in 1877 referred to as a "predominating affinity for those of our own kind."

A COLLEGE

In the spring of 1857, Edward Miner Gallaudet resigned his teaching position at the American School for the Deaf in Hartford—the school his father had cofounded—to begin a lucrative position at a Chicago bank. His plans changed abruptly, however, when he received a letter from Amos Kendall, a wealthy Washington, D.C. philanthropist, asking him to become superintendent of a new school for deaf students in the District of Columbia.

Kendall was politically astute and well connected. He had been a member of Andrew Jackson's "kitchen cabinet" of informal advisors and later Postmaster General under both Presidents Jackson and Martin Van Buren. Kendall also was a former newspaper editor and the legal guardian to five deaf orphans. He successfully lobbied Congress to incorporate a school

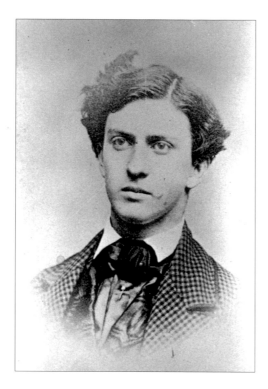

◀ Edward Miner Gallaudet was only twenty years old when Amos Kendall asked him to head a new school in Washington, DC. (Gallaudet University Archives, Washington, DC.)

▶ Gallaudet College buildings (*left to right*) College Hall, Chapel Hall, and "Old" Fowler Hall in Washington, DC. (Gallaudet University Archives, Washington, DC.)

and to finance the education of indigent deaf students in the District. He donated two acres of his land and a building in northeast Washington for the school, and then began the search for a qualified superintendent. His search led him to young Gallaudet.

Gallaudet, only twenty years old at the time, had other ambitions than to head a school. He had spoken enthusiastically with a fellow teacher, Jared Ayres, about the idea raised by John Carlin, a deaf poet and teacher, of a college for deaf students, but neither of them knew how to proceed unless "a millionaire might be found to endow it." Now he and Ayres wondered if Kendall might be that millionaire. When Gallaudet met Kendall in Washington, D.C., he broached the idea: "I unfolded to him my plans for a college and said that if he and his associates . . . would support me in these plans, I would accept their offer. They met my overtures with alacrity, pleased with the idea of having what they conceived of as no more than a small local school, grow ultimately into an institution of national importance and influence."

"Deaf mutes have no finished scholars of their own to boast of. . . . It is simply because they have no universities, colleges, high schools and lyceums of their own, to bring them through the proper course of collegiate education to a level with those human ornaments of the speaking community, who are indebted to the existence of their own above-named temples of learning for their superior attainments."

John Carlin, "The National College for Mutes," American Annals of the Deaf, *1854*

The Columbia Institution for the Deaf and Dumb and Blind opened its doors on June 13, 1857. This school, now called the Laurent Clerc National Deaf Education Center, is still in operation today. The bill to establish a national college for deaf students came before Congress in the midst of the Civil War. Southern states, then as now, were less likely to support public funding for educational purposes; had there been Southern representatives in Congress, it is

possible that the college would never have been established. As it was, the bill easily passed and President Abraham Lincoln signed it in April 1864. The inaugural ceremony took place on June 28th of that year, with addresses from distinguished speakers such as Laurent Clerc and John Carlin. Clerc's speech stressed the importance of education for deaf people. He noted that

> *The Romans, once the masters of the world, called the other nations, who did not know the language of Rome, barbarians; so, now that there are so many schools for the deaf and dumb in the United States, I will call* barbarians *those grown-up deaf-mutes who do not know how to read, write, and cipher.*

Carlin predicted that

> *The birth of this infant college, the first of its kind in the world, will bring joy to the mute community. . . . I thank God for this privilege of witnessing the consummation of my wishes, the establishment of a college for deaf-mutes, a*

subject which has for past years occupied my mind. . . . Is it likely that colleges for deaf-mutes will ever produce mute statesmen, lawyers, and ministers of religion, orators, poets, and authors? The answer is: they will.

The first students arrived in the fall of 1864, and the next year the school was named the National Deaf-Mute College. In 1866, the year the first bachelor's degree was awarded, Frederick Law Olmsted, the landscape architect who created New York's Central Park, developed a new design for the campus. The college began to accept deaf women as students in 1886. The alumni asociation was established in 1889. The institution was renamed Gallaudet College in 1894 in honor of Thomas Hopkins Gallaudet. Edward Miner Gallaudet retired from the college presidency in 1910, by which time the campus had expanded from its original two acres to ninety-two. The college became Gallaudet University in 1986. Through the years, Gallaudet has provided a place for deaf students to attend college,

◀ Dr. Edward Miner Gallaudet, the first president of Gallaudet College (now University) in his office. (Gallaudet University Archives, Washington, DC.)

▶ Preparatory (first-year) students were often required to wear beanies or other clothing to make them stand out on campus. These women were from a 1920s class. (Gallaudet University Archives, Washington, DC; from the collection of Rev. Robert and Mrs. Estelle Caldwell Fletcher.)

▼ The Harrison and Norton Club posed for this 1888 photo in front of Chapel Hall on the Gallaudet campus. Members of the club are fingerspelling "Harrison" and "Norton." Many such clubs existed on campus for social and academic purposes. (Gallaudet University Archives, Washington, DC.)

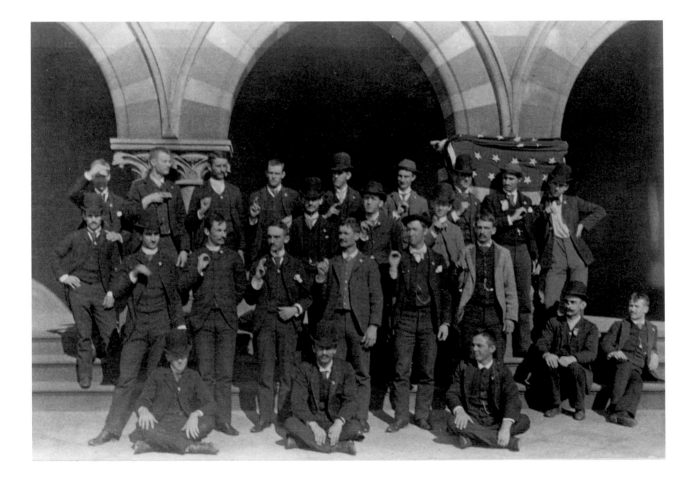

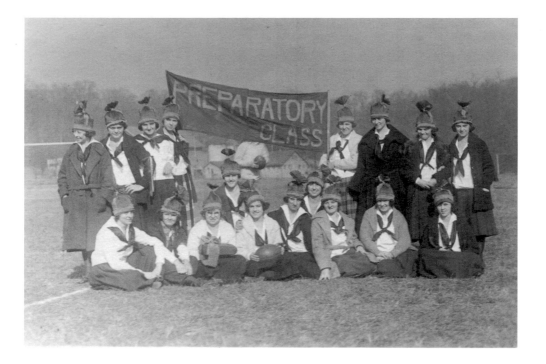

prepare for professional work, and assume leadership roles. Gallaudet also has contributed to the building of a stronger national Deaf community.

"I need not tell you that a mighty change has taken place within the last half century, a change for the better," Alphonso Johnson, the president of the Empire State Association of Deaf-Mutes, signed to hundreds of assembled deaf people in 1869. Johnson pointed to an important truth: the first half of the nineteenth century was a period of transformation for deaf Americans, a time that saw the rise of deaf education and the coalescence of the nation's deaf community. In 1816, no schools for deaf students existed in the United States, and people commonly perceived "the deaf and dumb" as uneducable. Many deaf individuals lived scattered, largely isolated from each other, and illiterate. Fifty years later, the nation had more than twenty-five schools for the deaf. These schools enabled deaf people to come together, gain an education, develop American Sign Language (ASL), and find their own collective identity; after their establishment, deaf organizations and publications gradually began to appear. Deaf people also became more visible in society, making an impression upon the nation's consciousness and challenging traditional stereotypes. When, in 1850, over four hundred deaf people assembled in Hartford, Connecticut, the event showed just how strong the deaf communal identity had become. And when, in 1864, Congress authorized the National Deaf-Mute College, the act affirmed just how much society's view of deaf people had evolved. Now, many Americans recognized deaf people as full human beings with talent and intellectual potential."

Christopher Krentz, A Mighty Change: An Anthology of Deaf American Writing, 1816–1864, *(Washington, DC: Gallaudet University Press), xi*

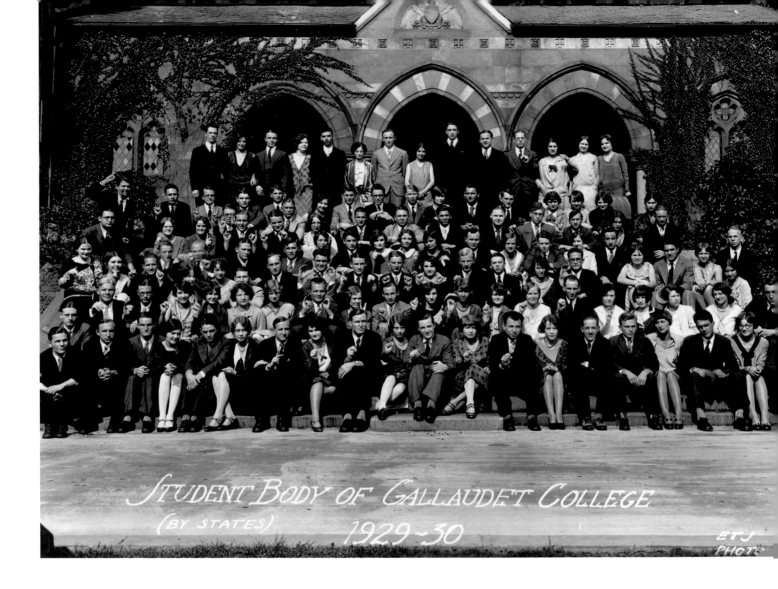

STUDENT BODY OF GALLAUDET COLLEGE
(BY STATES) 1929-30

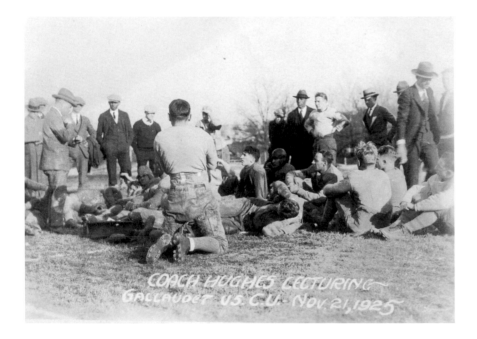

COACH HUGHES LECTURING~
GALLAUDET VS. C.U. NOV. 21, 1925

▲ A class photo from 1929–1930. Some students are signing the letters of their home state. (Gallaudet University Archives, Washington, DC.)

◀ Like most college campuses, Gallaudet had an active sports program. Here, Coach Hughes lectures to the 1925 football team. (Gallaudet University Archives, Washington, DC.)

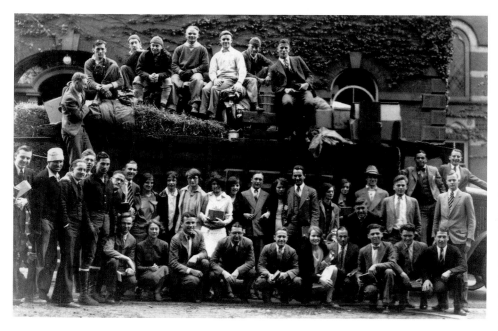

◀ Social outings such as this 1932 hayride were part of campus life. (Gallaudet University Archives, Washington, DC; collection of Elmer Ivan Curtis and May Koehn Curtis.)

▼ For its first eighty years, Gallaudet did not admit black students. Douglas Craig, who was deaf, lived on campus much of his life and worked to maintain the buildings and grounds. A campus street was named for him. (Gallaudet University Archives, Washington, DC; from the collection of Elmer Ivan Curtis.)

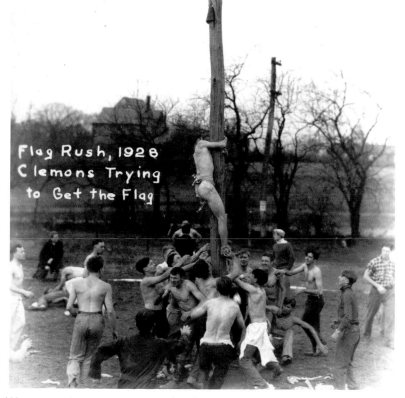

Women students were not permitted to attend activities such as this "Flag Rush." (Gallaudet University Archives, Washington, DC; from the collection of Elmer Ivan Curtis.)

CHAPTER FOUR

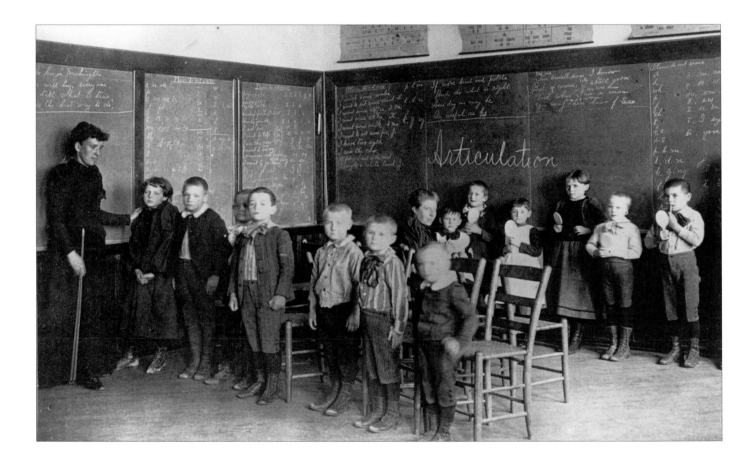

The Struggle over Sign Language

THE RISE OF ORALISM

The story of the suppression of sign language is well known in the folklore of the American Deaf community, but few hearing people are aware of it. In the decades following the Civil War, educational reformers waged a campaign to eliminate *manualism*—the use of sign language in the classroom—and to replace it with *oralism*, the exclusive use of lipreading and speech. Most residential schools had used the manual method from their beginnings; teachers conducted their classes in sign language, fingerspelling, and written English. Schools began to offer lessons in speech and lipreading in the 1860s and 1870s, moving toward what they termed a *combined method*. However, the advocates of oralism found this change to be insufficient; they opposed any use of sign language for any purpose.

Oralists charged that the use of sign language encouraged deaf people to socialize principally with other deaf people and to avoid the hard work of learning to communicate in spoken English. They thought that sign language marked deaf people as different from hearing people—it set them apart, discouraged assimilation, and invited discrimination. They worried

◀ In this articulation class at the Colorado School for the Deaf and the Blind, students in the back row use mirrors to learn to pronounce words. Oralists at the time believed that signing oppressed and isolated deaf people, and that it invited discrimination since it set them apart from the general population. Speech was the way to "emancipate" them. Many deaf leaders profoundly disagreed and portrayed oralists themselves as oppressors of deaf people. (Colorado School for the Deaf and the Blind, Colorado Springs, CO.)

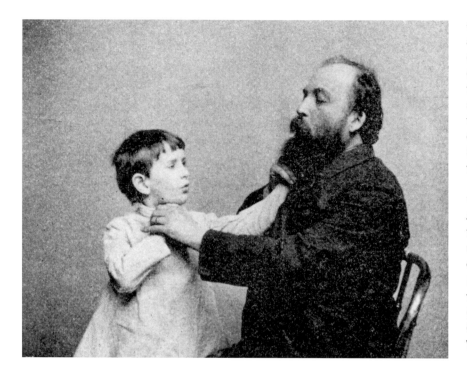

◀ During speech lessons, teachers and deaf students often touched each other's throats to feel vocal chord vibrations. In this photograph from 1893, a student is learning the sound of "o" at the New York Institution for the Improved Instruction of Deaf Mutes, now the Lexington School for the Deaf. (Gallaudet University Archives, Washington, DC.)

▼ The Principal's Group of the American Association for the Promotion of Teaching Speech to the Deaf met in Philadelphia in 1896. Alexander Graham Bell (*second row, center*), an oral education proponent, watches as two members sign. (Photograph by Alexander L. Pach; Gallaudet University Archives, Washington, DC.)

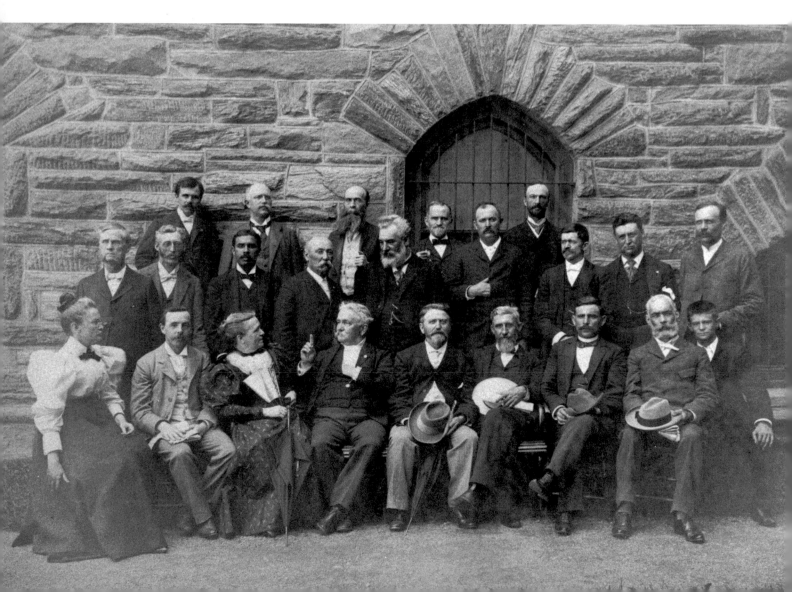

also that it encouraged deaf people to marry one another and that this was causing a significant increase in the prevalence of deafness.

> "Since speech has traditionally been forced upon Deaf people as a substitute for their language, it has come to represent confinement and denial of the most fundamental need of Deaf people: to communicate deeply and comfortably in their own language."
>
> *Carol Padden, "The Deaf Community and the Culture of Deaf People," in* Sign Language and the Deaf Community, *ed. Charlotte Baker and Robin Battison, 97 (Silver Spring, MD: National Association of the Deaf, 1980)*

- "Nature hates force. Just as the flowing stream seeks the easiest path, so the mind seeks the way of least resistance. The sign-language offers to the deaf a broad and smooth avenue for the inflow and outflow of thought, and there is no other avenue for them like unto it."
 George M. Teegarden, Gallaudet Class of 1876
- "From the standpoint of a totally deaf person, proficient in speech and lip-reading, and with forty years' experience in the art, I can only say that lip-reading at its best is a matter of skillful guess work, and a sorry mess we sometimes make of it."
 Anton Spear, Gallaudet Class of 1884
- "If you try to suppress signs you will teach deceit, for the deaf will always use it on the sly."
 Francis Maginn, Gallaudet Class of 1889
- "It is a lamentable fact that, in matters relating to the deaf, their education and well-being, few if any take the trouble to get the opinion of the very people most concerned—the deaf themselves."
 John H. Kelser, Gallaudet Class of 1905

A fierce debate ensued between supporters of the combined method and advocates of pure oralism. In the end, the oralists largely succeeded in their campaign to eliminate sign language from the classroom. By 1920, 80 percent of deaf students were taught without sign language, and the teaching corps at residential schools went from being 40 percent deaf to less than 15 percent. The oralists' larger aim to end the use of sign language among deaf people and weaken their bonds to one another, however, was a failure. In most schools, deaf students continued to use sign language outside of the classroom in spite of efforts to forbid or discourage its use. Away from the schools, sign language remained the dominant means of communication for the great majority of deaf people.

> "So long as the world stands, a deaf child will make signs.... Abolish the gesture language today, and, so surely as one deaf person remains above ground, another and perhaps more copious gesture language will take its place tomorrow."
>
> *Sarah Porter, "The Suppression of Signs by Force," American Annals of the Deaf 39 (June 1894)*

FOREIGNERS AMONG THEIR OWN COUNTRYMEN

Why did hearing Americans turn against sign language? One explanation may be that, after the devastation of the Civil War, many people began to fear that cultural differences within the nation were dangerous and ought to be suppressed. Then, increasing levels of immigration from Eastern and southern Europe caused even more apprehension over ethnic, racial, and linguistic diversity. The patchwork of immigrant communities crowded into burgeoning

"Under the oral system the development of the mental faculties is subordinated to the development of speech. It is assumed that with speech will come the power of expression, for 'speech is expression and expression is speech.' Years of labor are spent in mechanical drill upon vocal sounds, a process which results in permanently dwarfing the mental faculties."

George Wing, graduate of the American School for the Deaf and instructor at the Minnesota School for the Deaf, 1886

Ruth Lovella (Benson) (*above*) received oral training at a school in St. Paul, Minnesota, ca. 1922. Touching areas of the mouth that produce certain sounds was a method of instruction in many schools. (Courtesy of Richard Schoenberg.)

"If speech is better for hearing people than barbaric signs, it is better for the deaf; being the 'fittest, it has survived.' The power of speech and lip-reading bring the deaf into general communication with mankind, and this improves them mentally; the natural and free exercise of their lungs improves them physically; and the feeling that they are being made like their kind, instead of being peculiar and separate from them, rouses in them an ambition which improves them morally."

Emma Garrett, oral educator, 1883

THE CONCEPT OF NORMALITY

Like all ideas, this misapplication of evolutionary theory did not travel alone. One of its most influential companions was the emerging concept of normality. The word *normal* first began to acquire its modern meaning of *typical* or *average* in the middle decades of the nineteenth century. Nonetheless, it has never adhered to its dictionary definition; in common usage, *normal* functions simultaneously as both description and prescription, signifying both what *is* and what *ought to be.*

Deaf people and manualist educators had long referred to sign language as the "natural language of signs." By this, they meant to suggest not only that sign language was natural to deaf people, but also that it was a more natural means of communication for all humans. As evidence, they pointed to the fact that children gesture before they speak and that travelers spontaneously resort to gesture as a universal means of communication. Oralists countered that spoken language had been the norm for millennia.

The earlier generation of manualists had asked what the essence of human nature was and what humans were beneath the veneer of civilization, and they had used the answers as a guide to right conduct. Oralists, however, came of age in the midst of

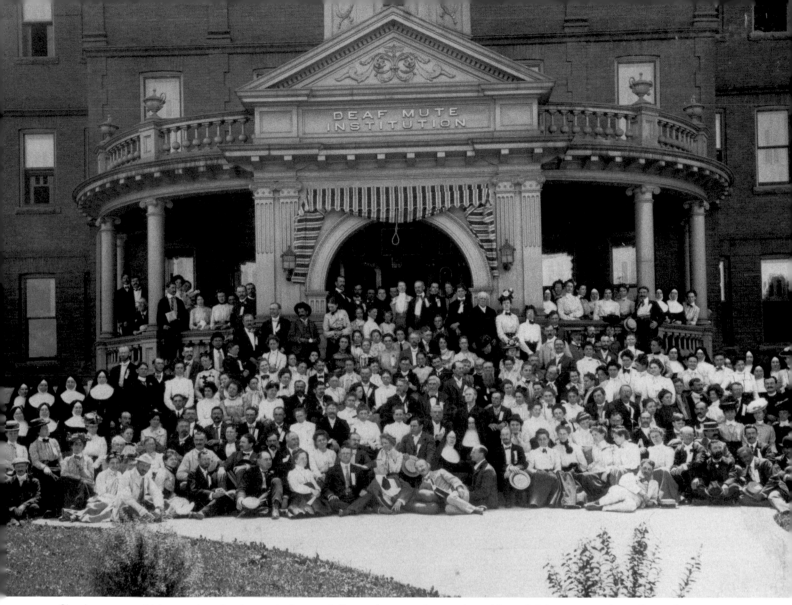

Sign language, which was described as part of an evolutionary framework, was the subject of debate at meetings of superintendents and school principals, such as this 1901 Convention of American Instructors of the Deaf conference, held at St. Mary's Institution for the Deaf in Buffalo, New York. (Gallaudet University Archives, Washington, DC.)

rapid urbanization and industrialization with its demands for standardized measurements, mass production, interchangeable parts and workers, and the management of large populations. Their generation tended to frame all questions in terms of the statistical norm, which was displacing the Enlightenment idea of an underlying human nature as a core organizing principle in Western culture. A greater emphasis on social conformism was the result.

As the concept of normality became increasingly important in American culture, teachers of deaf children began using the term *normal* rather than *hearing*. They contrasted the development of deaf children to "normal children" and discussed how their work, as teachers "of the abnormal child," compared with "ordinary work with the normal child." While deaf people themselves never accepted this terminology and continued to use the phrase

hearing people, the concept of normality came to dominate the way that professionals and the public thought and spoke about deaf people. "Our first and foremost aim," wrote a teacher in 1907, "has been the development of the deaf child into as nearly a normal individual as possible."

> "Deafness is rarely discovered in the young child until he reaches the age of two or more years when he would naturally begin to talk. . . . In the struggle to make himself understood he invents crude gestures and the longer he uses these, the more peculiar and abnormal he grows."
>
> *Mary McGowen, founder of the McGowen Oral School for Young Deaf Children in Chicago, 1904*

A student listens as her teacher speaks into a tube at the McGowen Oral School in Chicago. The tube funnels sound to the student's ear. Teachers used this kind of "auricular" training to try to stimulate children's residual hearing. (From *Histories of American Schools for the Deaf, 1817–1893*, ed. Edward Allen Fay [Washington, DC: Volta Bureau, 1893]; Gallaudet University Archives, Washington, DC.)

While oralists conceded that deafness made complete normality impossible, they held it to be a goal worthy of unending pursuit nevertheless. If deaf people fell short of normal, they might still be made less obviously abnormal. An overly optimistic writer for *Scientific American* proclaimed in June 1907 that, with oral instruction, "congenital mutes are . . . able to speak so perfectly, that it is difficult to distinguish their voices from those of normal persons." Unrealistic as it may have been, the measure of success now was to *pass* for a normal person.

> "Can you think what it is to go through life as one of a peculiar class? It is the sum of human misery. No other human misfortune is comparable to this . . . the individual must be one with the race or he is virtually annihilated. Peculiarity is forever the mark of Cain . . . And believe me this peculiarity is not inevitable. It is solely the result of deaf children being shut up in sign schools."
>
> *Katharine Bingham, mother of a deaf son, 1900*

THE MILAN CONGRESS

Europeans as well as Americans turned against sign language, and for similar reasons. In 1880, an international group of educators of the deaf met in Milan, Italy, and their deliberations became the symbolic turning point in the campaign for pure oralism. The "Milan Congress" was organized and promoted by French and Italian oralists who hoped to use the conference to advance their cause. Though open to all educators, 143 of the 164 attendees were oral advocates from France and Italy. James Denison, the principal of the Kendall School in Washington, DC, was the only deaf person present. He was part of the American delegation, which also included Isaac Lewis Peet and Charles A. Stoddard

"After the Milan Congress, the percentage of deaf teachers dropped because they couldn't teach speech. Those schools that were strong supporters of deaf teachers moved them to the vocational programs to avoid parents' objections. Those were the dark ages for deaf education in America."

Jack R. Gannon

(both from the New York Institution for the Deaf), Edward Miner Gallaudet, and his brother Thomas Gallaudet. When the conference president, the Abbé Guilio Tarra, proposed a resolution endorsing oralism (after a presidential address that continued for two days!), it passed with only six dissenting votes—the five Americans and one Briton. At the close of the congress, a French representative shouted from the podium, "*Viva la parole!*" (Long live speech!).

"The timing of the oralist onslaught . . . was fortunate for the cause of sign language in the United States. The deaf community already had begun to organize itself; its communication network was in place; and it had a core of educated and forceful individuals to lead it. The NAD originated at a meeting in 1880, just one month before the Milan Congress. School Little Papers were ubiquitous by the late nineteenth century, and their pages carried an endless stream of articles about the fate of sign language and the challenge of oralism. Stronger articles appeared in the independent deaf press . . . Thus, when the challenge did come, the deaf community was to some extent prepared."

John Vickrey Van Cleve and Barry Crouch, A Place of Their Own: Creating the Deaf Community in America (Washington, DC: Gallaudet University Press, 1989), 128–29

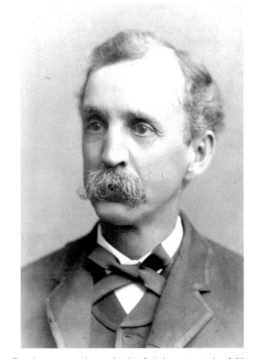

James Denison was the only deaf delegate at the Milan Congress. He, along with five other participants, voted against the resolution endorsing oralism. (Gallaudet University Archives, Washington, DC.)

The vote in Milan was stacked against manualism and overstated the support for oralism among teachers at the time. Nevertheless, it did accurately represent the direction of the tide as well as the hopes of the public. Credulous newspapers such as the *Times* of London reported that Italian deaf students exhibited at the conference were "addressed just as if they were not deaf, in spoken language, and

they one and all answered in spoken language." The journalists failed to inquire into such details as the students' degree of hearing loss, or whether their hearing loss dated from birth or had occurred after they had already learned to speak. Moreover, the Americans noticed that, in many instances, the examiners had not completed their questions before the students began to answer. Neither the lack of scientific rigor nor the obvious bias at the Milan Congress, however, prevented it from becoming a public relations coup for the oralist cause.

"Has the poet the right to sing? Has the orator the right to sway men, not only by what he says, but by the way he says it? Has the musician the right to charm by melody, or stir the deepest depth of human feeling by great music? Has the human voice the right to soar in glorious song from the throat of some marvelous vocalist until men and women are almost on their feet with delight? Have you, dear reader, the right to chat without effort or strain with your friends, claiming free and unrestrained intercourse in conversation as a natural birthright?

"If so, then the deaf-mute has a right to some kind of language whose chief power and charm for him shall be in expression."

A Semi-Deaf Lady, "The Sign Language and the Right to Expression," American Annals of the Deaf *(March 1908), 141–42*

ALEXANDER GRAHAM BELL

Most Americans know Alexander Graham Bell as the inventor of the telephone, but few are aware that the central interest of his life was deaf education or that he was one of the most prominent proponents of oralism in the United States. Like his father before him, Bell spent his life studying the physiol-

ogy of speech. He once said that "to ask the value of speech is like asking the value of life." After emigrating from England to Canada in 1870 and to the United States a year later, Bell began to teach speech to deaf students using a universal alphabet invented by his father called "Visible Speech." In 1872, he opened a school in Boston to train teachers of deaf children.

Bell's second chief interest was the study of heredity and animal breeding, and he became an early supporter of the eugenics movement to improve human breeding. Bell did not go so far as to advocate social controls on reproduction, as many eugenicists did, but he decried the immigration into the United States of what he termed "undesirable ethnical elements." He called for legislation to prevent their entry in order to encourage the "evolution of a higher and nobler type of man in America." His views on immigration, deaf education, and eugenics overlapped and intertwined. He described sign language as "essentially a foreign language" and argued that "in an English speaking country like the United States, the English language, *and the English language alone,* should be used as the means of communica-

"Society in general views Alexander Graham Bell as an American hero, as the inventor of the telephone. He was famous, wealthy, and influential. His own mother was deaf. He was always associating with the Deaf community and he was a teacher of deaf children. He had his own day school in Boston. He was very familiar with the Deaf world."

Brian Greenwald

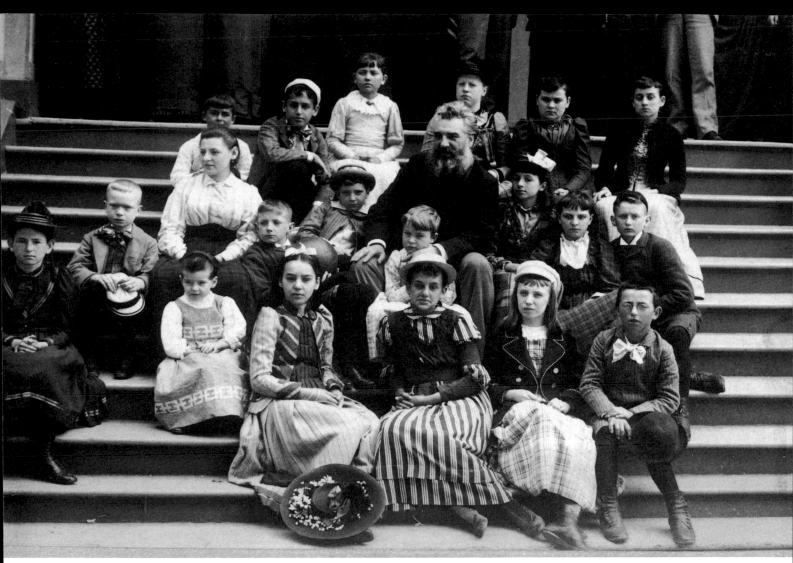

Alexander Graham Bell, pictured here with students from the Clarke Institution for the Deaf, was a pragmatist who was willing to use sign language or other means to communicate with deaf adults. With children, however, he advocated a strictly oral education, without any signing. (Clarke School for the Deaf–Center for Oral Education, Northampton, MA.)

tion and instruction—at least in schools supported at public expense." He maintained that the use of sign language "in our public schools is contrary to the spirit and practice of American Institutions (as foreign immigrants have found out)."

In 1883, Bell presented a paper titled "Memoir upon the Formation of a Deaf Variety of the Human Race," in which he warned of a "great calamity" facing the nation: deaf people were forming clubs, socializing with one another and, consequently, marrying other deaf people. The inexorable result would be the creation of a "deaf race" that yearly would grow larger and more insular. Bell

noted that "a special language adapted for the use of such a race" already was in existence, "a language as different from English as French or German or Russian." Some eugenicists called for legislation outlawing intermarriage by deaf people, but Bell rejected such a ban as impractical. Instead he proposed the following steps: "*(1) Determine the causes that promote intermarriages among the deaf and dumb; and (2) remove them.* The causes he sought to remove were sign language, deaf teachers, and residential schools. His solution was the creation of special day schools staffed by hearing teachers who would enforce a ban on sign language.

Mr. Bell - -

Daisy Bell - -

Elsie Bell - -

- - Mr. Bell

Mr. Bell is Elsie's papa and Daisy's papa too.
Mrs. Bell is Elsie's mamma and Daisy's mamma too.
Mrs. Bell is Mr. Bell's wife.
Mr. Bell is Mrs. Bell's husband
Mr. and Mrs. Bell are the parents of Elsie and Daisy.
Elsie and Daisy are the children of Mr. and Mrs. Bell.

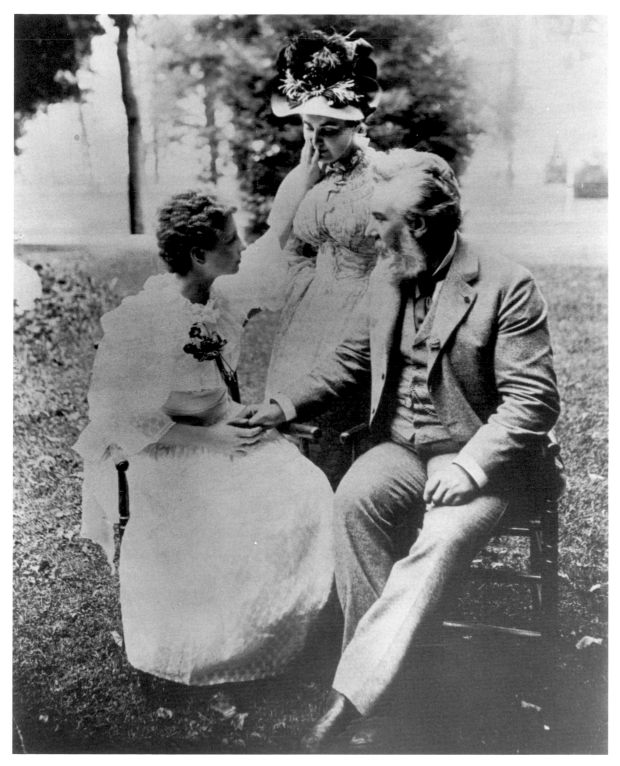

◀ Alexander Graham Bell labeled and wrote sentences on this family photograph and placed it in a notebook for the deaf students in the private school he established and ran in Washington, DC, from 1883–1886. His wife, Mabel Hubbard Bell, was deaf and a skilled speechreader. His mother (not pictured) was also deaf. (Gallaudet University Archives, Washington, DC; from the Volta Bureau, Washington, DC.)

▲ Bell was helpful in finding a teacher for Helen Keller, who was deaf and blind. Here, Keller and Bell talk with assistance from Anne Sullivan, Keller's teacher and mentor. (Library of Congress, Prints and Photographs Division, LC-G9Z1-137,816-A, Washington DC.)

spondents, artists, and photographers. Its editor, George S. Porter, possessed extraordinary expertise and a wide range of interests. His editorials covered such topics as what the tsar should be doing for deaf people in Russia, the schools for the deaf in Venezuela, and raising money to establish schools for the deaf in China. The *Silent Worker* thrived until 1929, when a long-simmering conflict with the New Jersey school superintendent came to a boil. The superintendent, angry at criticisms from deaf teachers and the *Silent Worker* that the school under his direction had become excessively focused on speech and lipreading to the detriment of intellectual development, fired the remaining deaf teachers in the school's academic departments and closed down the paper. The *Silent Worker* was replaced by the *Jersey School News*.

This teacher and student at the Clarke School for the Deaf watch each other's lips in a mirror during a speech lesson. All of the teachers at the Clarke School (originally, Institution), from its founding in 1867 through 1904, were women. (Clarke School for the Deaf–Center for Oral Education, Northampton, MA.)

"Parting from the *Silent Worker* is like parting from an old friend. My connection with this magazine has been very pleasant. Through it I have enjoyed the friendship of many brilliant writers in the deaf world. Through them this magazine has been able to present many articles of historical value, and the deaf in general have been elevated to a higher plane. In retiring there is one consolation that will cling to me as long as I live—that of the hundreds of boys who were once my pupils now earning a comfortable living by following the printers' and photo-engravers' trades . . . But time brings many changes . . .New ideas . . . New methods . . . New theories . . . New conditions . . . Such is life. Good bye."

George S. Porter, The Silent Worker, *June 1929*

The National Association of the Deaf resurrected the *Silent Worker* as its official periodical in 1948. The first issue proclaimed, "The *Silent Worker* lives again!" and featured stories on George Porter

and the remarkable history of its forerunner. The newspaper continued under the same name until 1964 when, at the height of the Cold War, its publishers became concerned that the title called to mind the paper of the American Communist Party, *The Worker*, and changed it to the *Deaf American*.

WOMEN IN THE CLASSROOM

Following the Civil War, teaching in schools for deaf students came to be a predominantly female occupation. The carnage of the war had decimated the ranks of male teachers; at the same time, more women began to attend college and acquire teaching credentials. The schools also had a strong financial incentive to hire women. Deaf teachers had always provided low-cost labor at the schools, being paid far less than their hearing counterparts, but oral schools were generally opposed to hiring deaf teachers. The oral method required very small classes and, therefore, a larger

Teachers used a variety of methods to teach students about sound. This young girl is feeling vibrations through a drum. (Gallaudet University Archives, Washington, DC.)

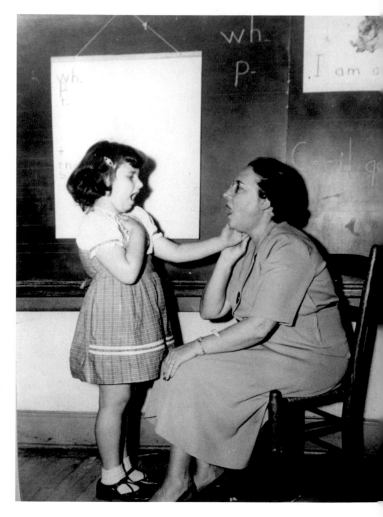

teaching staff. Hiring women as teachers, and paying them half the salary of hearing men, helped to offset the increased costs associated with oral methods.

Many people believed that female teachers were better suited to providing oral training, which required painstaking, repetitive work in close contact with young students. Franklin B. Sanborn, the president of the Clarke Institution, remarked that the gentlemen "who manage the pecuniary affairs of this Institution are only too glad to commit the management of these children and the incessant task of their education to the patient hands, the active tongues, and the conscientious fidelity of women."

"In glancing at the teacher's salaries . . . we noted . . . the great discrepancy between salaries of the teachers with regard to sex . . . In the name of all that is just and equitable, why is this so?"

Laura Redden, Missouri School for the Deaf graduate who wrote under the pen name of Howard Glyndon

DEFENDING SIGN LANGUAGE

As oralism became the dominant method of communication in schools for deaf students, the National Association of the Deaf and other community organizations rose to the defense of sign language in the classroom. Deaf leaders called it the "natural language of the deaf" and argued that a reliance on oral communication alone would be educationally disastrous for most deaf students.

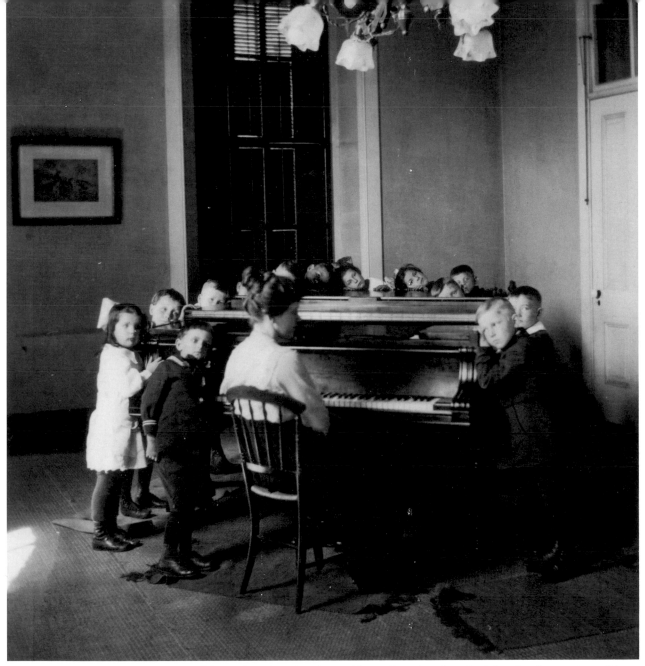

Rhythm was taught at many schools. This teacher plays the piano while students lean in to feel the vibrations and possibly hear some sounds. (Maryland School for the Deaf, Frederick.)

They took the debate to Deaf community newspapers, to journals of education, to teachers' conventions, to any forum accessible to them. As early as 1873, Benjamin Pettengill of the Pennsylvania Institution wrote in the *American Annals of the Deaf* that no one had ever produced any evidence that sign language interfered with the proper use of English, and furthermore that "the children of deaf-mute parents who have used signs . . . from their infancy, invariably, other things being equal, attain to a correct use of written language sooner than other congenital deaf-mutes." The National Association of the Deaf published position papers describing the failures of pure oralism that they then used in lobbying state legislatures and school boards.

"Let me repeat once more that the Sign language cannot be, and never will be abolished. Let me also repeat that the sign language is not responsible for any lack in the education of the deaf-mute—the pure oralists to the contrary notwithstanding. Their efforts covering a century have been thoroughly tested and have been proved a failure. In fact they have helped to make me bitter, for I have been one of the victims."

Albert Ballin, The Deaf Mute Howls *(Los Angeles, Grafton Publishing Co.,1930; Washington, DC: Gallaudet University Press, 1998), 61.*

Nevertheless, the Deaf community began to take steps to preserve its language if worse should come to worst. In 1909, J. Schuyler Long, a teacher at the Iowa School for the Deaf, published a dictionary, *The Sign Language: A Manual of Signs*, to "preserve this expressive language, to which the deaf owe so much, in its original purity and beauty." The National Association of the Deaf began its own project, the production of a series of films, in 1910, under the direction of its president, George Veditz. The NAD raised $5,000 (the equivalent of nearly $100,000 today) to make eighteen films. This was a great deal of money for the small and chronically cash-poor organization. NAD undertook the project out of fear that the elimination of sign language and deaf teachers in the schools would lead to the deterioration of their beloved language and out of hope that the new technology of film could preserve examples of the "masters of our sign language" for future generations. Veditz's own contribution to the film series, an impassioned call for "The Preservation of the Sign Language" (the title of his speech), denounced the damage caused by the "false prophets" of oralism. Because sign languages have no written form, these films provide the earliest glimpse of the language Deaf Americans created.

In the end, the extensive network of Deaf community organizations and the stubborn tendency of deaf students to use signs whenever out of the sight of school officials prevented oralists from claiming a complete victory. Deaf parents signed to their children, and those children who were deaf surreptitiously passed linguistic and cultural knowledge to their schoolmates. While American Sign Language survived intact, the care that Veditz and his contemporaries took to preserve it out of fear that it might be lost forever, presents the best evidence that the language of Deaf Americans today is the same language handed down from the nineteenth century.

"We American deaf are now facing bad times for our schools. False prophets are now appearing, announcing to the public that our American means of teaching the deaf are all wrong. These men have tried to educate the public and make them believe that the oral method is really the one best means of educating the deaf. But we American deaf know, the French deaf know, the German deaf know that in truth, the oral method is the worst. A new race of pharaohs that knew not Joseph is taking over the land and many of our American schools. They do not understand signs for they cannot sign. They proclaim that signs are worthless and of no help to the deaf. Enemies of the sign language, they are enemies of the true welfare of the deaf. We must use our films to pass on the beauty of the signs we have now. As long as we have deaf people on earth, we will have signs. And as long as we have our films, we can preserve signs in their old purity. It is my hope that we will all love and guard our beautiful sign language as the noblest gift God has given to deaf people."

George Veditz, "The Preservation of the Sign Language," 1913; translated from ASL by Carol Padden and Eric Malzkuhn

In 1913, George Veditz filmed "The Preservation of the Sign Language" as part of the National Association of the Deaf's effort to document master signers. (Gallaudet University Archives, Washington, DC; from the collection of the National Association of the Deaf.)

"Beginning the century as isolated individuals, coming from diverse ethnic and regional backgrounds, and usually raised by parents whose culture they would never share completely, deaf people had fashioned a subculture and a community that paralleled those of immigrant groups and that satisfied the particular needs of persons who were deaf. Deaf Americans welcomed the twentieth century with their own visual language, their own churches and ministers, their own clubs and associations, and their own newspapers. Like members of the most closely knit ethnic groups, they married each other almost exclusively. They had withstood challenges to the legitimacy of their culture and to their right to form a group within yet apart from hearing society."

John Vickrey Van Cleve and Barry Crouch, A Place of Their Own: Creating the Deaf Community in America *(Washington, DC: Gallaudet University Press, 1989), 169*

CHAPTER FIVE

In Time of War and Economic Depression

FINDING WORK

In the first half of the twentieth century, Deaf Americans continued to fight for sign language in the schools, but prejudice against it remained strong and they had few successes. The intransigence of the schools on the language issue and the rapidly changing and increasingly unstable economy led Deaf community organizations to turn their attention to other issues, particularly employment.

During the nineteenth century, most Americans had lived and worked in rural areas and small towns, on farms and in small shops. In this handicraft and farm economy, Deaf people had faced few obstacles. Residential and day schools trained students in a variety of trades in which the lack of hearing was not a barrier. By the early twentieth century, however, the country was in the midst of a massive shift from an agricultural to an industrial economy, and large numbers of rural dwellers moved to the cities to look for work. Americans became more dependent upon wage labor than ever, but employment was less and less stable. The economy was expanding from a regional to a national and even global base, and the government did little to soften business cycles. Beginning in the 1890s, the economy alternated between boom and bust, with increasingly difficult recessions that culminated in the Great Depression of the 1930s. Deaf workers had to find their way in a competitive and rapidly changing job market.

◀ War created job opportunities for many deaf men and women. This woman, Dorothy Herran, is riveting metal at the Firestone Tire and Rubber plant in Akron, Ohio. (Gallaudet University Archives, Washington, DC.; from the collection of Benjamin Schowe, Sr.)

Employment has always been an especially difficult issue for the Deaf community. Unlike ethnic groups that clustered in geographic areas and created businesses that were handed down to succeeding generations, most deaf people came from hearing families and were often denied the job knowledge, skills, and connections usually passed down from elders to children. Cut off from this intergenerational transfer of capital, know-how, and relationships, each Deaf person was a first-generation settler in a new land, thrown upon their own resources to make their own way.

> "Attempts to promote a 'new public image of deaf' as self-reliant and productive were not new. But, by the early twentieth century, the perceived need for such attempts had greatly increased as discrimination and misperception created greater barriers for Deaf people. . . . Early efforts to counter worker discrimination through public education and organized job placement began at the grass-roots level."
>
> *Susan Burch*, Signs of Resistance
> *(New York: New York University Press, 2002), 113*

In the new, intensely competitive environment of the twentieth century, employment became a pressing issue for deaf people and their organizations, which devoted an increasing portion of their efforts to persuading employers that deaf workers made competent and reliable employees. Warren Robinson, the head of the NAD's Bureau of Industrial Statistics, wrote in a 1906 report that "the industrial question . . . is becoming more and more the question of the hour with the deaf." Articles on the employment question or offering advice on finding work soon became a common feature of many Deaf community publications. The activities of most Deaf organizations and writers reflected a strong

self-help ethic that emphasized improving job-seeking skills while educating employers on the benefits of hiring deaf workers.

During the 1930s, these efforts ran aground on the shoals of the Great Depression. All across the country, banks failed, factories shut down, and businesses closed their doors. Farmers were hit especially hard, with farm income falling by nearly half. By 1932 approximately one out of every four Americans was unemployed and many more were seriously underemployed. Franklin Delano Roosevelt won the presidential election that year, and early in his first term, he launched a blizzard of programs, known collectively as the New Deal, to put Americans back to work. The Civilian Conservation Corps (CCC), for example, placed two million young men in a variety of conservation projects, including planting trees, creating wildlife sanctuaries, and clearing trails. However, the CCC refused to hire deaf or otherwise disabled workers during its entire nine years in existence. Another program, the Works Progress Administration (WPA), at times excluded deaf people from jobs, and at other times did not; the National Association of the Deaf was in almost constant negotiation with WPA administrators over deaf access to its programs.

> "The admission of deaf applicants to the CCC seemed assured because thousands had already proven themselves at the demanding physical labor envisioned by the corps. As more than two million adults and families traversed the United States in search of food and work in the spring of 1933, administrators from the Departments of Agriculture, Interior, War, and Labor hastily established CCC rural work camps throughout the country. Entrance requirements were straightforward: applicants needed to be free from physical conditions that would make it 'impossible or inad-

visable to attempt hard physical labor in the forests.' Although they clearly seemed eligible, deaf applicants were uniformly refused admission to the CCC. Between 1933 and 1942, more than two million American men labored in the nation's forests and parks, but not one tree was felled or one mile of trail cleared by a deaf man."

Robert Buchanan, Illusions of Equality: Deaf Americans in School and Factory 1850–1950 *(Washington, DC: Gallaudet University Press, 1999), 92–93*

THE CIVIL SERVICE BATTLE

Deaf community anxieties about employment crystallized in a battle to maintain access to Civil Service jobs with the federal government. Prior to passage of the 1883 Civil Service Reform Act, all federal jobs had been subject to political appointment. Known as the "spoils system"—as in, "to the victor belongs the spoils"—each incoming presidential administration could fire as many current federal employees as they wished and then distribute the jobs to their own supporters. New administrations faced lines of job-seekers thronging the corridors of government buildings, including the White House, asking for jobs. Abraham Lincoln wrote of being accosted by job seekers right outside his bedroom door.

The Civil Service Reform Act of 1883 changed all this. The law established neutral criteria by which qualified applicants could obtain federal positions and protected them from being arbitrarily replaced by a new administration. By the 1890s, these procedures had resulted in the increased hiring of minorities; at the same time, the Civil Service Commission maintained a lengthy list of conditions, including blindness, paralysis, epilepsy, and loss of limbs, that automatically disqualified certain disabled people from consideration.

In the fall of 1906, the Civil Service Commission added *total deafness* and *loss of speech* to the list. In response to complaints from job candidates who had passed the required exams but were subsequently rejected by local officials due to their deafness, the commissioners decided that the easiest solution was simply to bar deaf people from taking the exams altogether. This, they thought, would head off any more rejections of otherwise qualified applicants and the resulting frustrations.

Word of the new rule spread throughout the Deaf community, which was poised to take advantage of the steady growth of Deaf organizations over the past couple of decades. Ready-made forums existed for Deaf leaders around the country to plan and coordinate a response to the federal government. Statewide associations organized letter-writing campaigns by their members. Deaf newspapers ran articles and outraged editorials. Ministers of Deaf churches preached sermons denouncing the new regulation. At Gallaudet College, the alumni association gathered for an emergency meeting.

While an alumni association might not seem to be the kind of organization that would take a leading role in a protest movement, Gallaudet's was another matter entirely. Only a very few deaf people had college degrees (at the time, relatively few hearing people had them either), and practically every one of them had graduated from Gallaudet. They represented the very elite of the Deaf community and, consequently, their organization had great prestige within it. The alumni association decided to take two actions. One was along the lines of previous Deaf community efforts to promote employment for their members—they surveyed deaf workers and their bosses in government to gather evidence that deaf workers were good employees. This project was highly successful; the surveyors gathered many letters from employers stating that deaf workers in government were valuable employees who did good work.

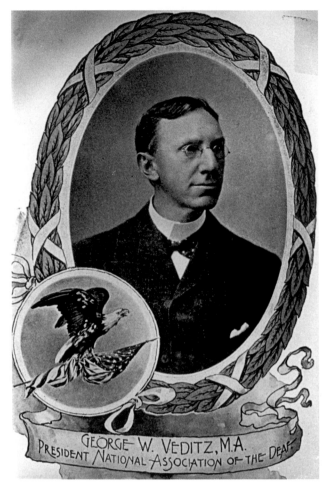

George Veditz was president of the National Association of the Deaf from 1904 to 1910. He fought for many issues affecting deaf people, particularly employment and access to sign language in education. (Gallaudet University Archives, Washington, DC.)

In a departure from previous Deaf community activism, the Gallaudet College Alumni Association also began organizing for political action. Several of its leading members coordinated a national campaign in opposition to the new Civil Service rules. George Veditz one of the alumni leaders submitted articles to newspapers in the Deaf press around the country warning that if the federal government stopped hiring deaf people, private employers would conclude, "if the deaf-mute is not good enough for Uncle Sam he is not good enough for me." The policy would be merely the first step in an unfolding

disaster for deaf workers: "No action ever taken so far in the history of the American deaf has been as inimical to their material welfare." Deaf people across the country, local clubs, state associations, and the NAD sent letters and resolutions of protest to the Civil Service Commission. The president of the Empire State Association declared that if deaf people were not entitled to the rights of citizens, they had no obligation to pay taxes either, adding "What is it to be deaf? Surely it is no crime." Deaf leaders recruited school superintendents, who usually had close relations with state legislators and governors, to join the protest. The president of Gallaudet College, Edward Miner Gallaudet, worked his connections in Congress and the federal government.

Two years passed without results. While these efforts were going forward, Deaf leaders turned to lobbying the 1908 presidential candidates. The sitting president, Theodore Roosevelt, had been unresponsive, but his chosen successor, William H. Taft, agreed that deaf candidates ought to be permitted to apply for positions for which they were qualified. William Jennings Bryan was noncommittal, expressing sympathy but no promises. The Socialist Party candidate Eugene Debs made the strongest statement, pledging to end discrimination against "our deaf-mute brothers." Given that Debs had little chance of winning, however, Veditz and others decided that Taft was their best bet. They were right—Taft won the election. In November 1908, before Taft took office, President Roosevelt rescinded the rule in accordance with Taft's position.

"After Taft's election, deaf leaders nonetheless persisted in their efforts to have President Roosevelt overturn the policy before Taft's inauguration. In late November, Olof Hanson of the Puget Sound Association of the Deaf forwarded a fervent letter to the president, asking him to

imagine his feelings if his son were to become deaf and therefore excluded from applying for positions for which he was capable. . . . In late November 1908, President Roosevelt repealed the exclusionary ruling."

Robert M. Buchanan, Illusions of Equality: Deaf Americans in School and Factory 1850–1950 *(Washington, DC: Gallaudet University Press, 1999), 47–48*

This victory proved to the Deaf community that it was possible to unite around an issue and fight to a successful conclusion. Veditz told the NAD meeting that year that they had succeeded because "the deaf themselves were a unit and fought shoulder to shoulder." Another member rejoiced that "the mighty Civil Service fell, and great was its fall. As a result, the deaf will henceforth be regarded as a positive quantity of the first rank."

"I am myself deaf. My greatest obstacle is not my deafness, but to overcome the prejudice and ignorance of those who do not understand what the deaf can do.

No action in reference to the deaf has caused such universal indignation among the deaf and their friends as has this ruling of the Civil Service Commission."

Olof Hanson, November 18, 1908, in a letter to President Theodore Roosevelt (Gallaudet University Archives, Washington, DC)

Deaf advocacy in employmemt had triumphed. In contrast, the struggles to keep sign language in the schools were marked mostly by failure. Deaf people understood that issues involving children aroused strong passions in parents, and they realized that they would always be at a disadvantage because most hearing parents were naturally disposed to favor oral communication over sign language for

Olof Hanson (1862–1933) was a Gallaudet alumnus and an architect. He was also a strong advocate of employment rights for deaf workers. His 1908 letter to President Theodore Roosevelt helped to change a civil service ruling. (Gallaudet University Archives, Washington, DC.)

their children. Employment, however, involved only adults, and in this area deaf adults advocated on their own behalf. The Civil Service campaign would be the first of many around the issue of employment. Moreover, while the Deaf community directed most of its efforts to self-help measures, their success in the Civil Service struggle convinced some Deaf leaders to turn their attention to more organized social means of improving work opportunities for deaf people. By 1910, for example, the NAD had established a committee to keep watch on government hiring practices and to investigate any complaints of discrimination against its members. It signaled the beginning of a century of increasingly activist politics by the Deaf community.

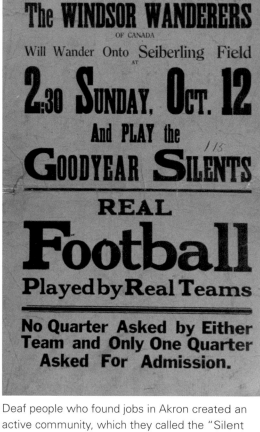

Deaf people who found jobs in Akron created an active community, which they called the "Silent Colony." They strongly supported and regularly attended The Goodyear Silents football games. This poster stresses that the games were "real football played by real teams." (Gallaudet University Archives, Washington, DC.)

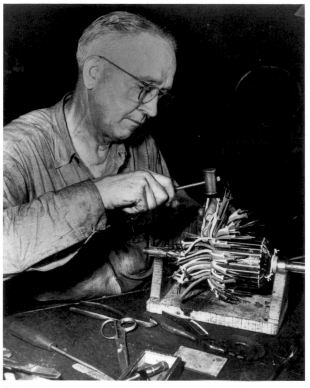

Firestone Rubber and Tire Company employed large numbers of deaf workers during World War II. This employee, seen working in 1942, is an armature winder. He repaired or replaced burnt and damaged coils in electric motors. (Gallaudet University Archives, Washington, DC; from the collection of Benjamin Schowe, Sr.)

"There were only a few more weeks of school and none of us had decided definitely what we'd do the next year. . . . We weren't quite ready to face up to really cutting loose from everything familiar and dear, and this place was a second home now. . . . What to do? Come back? Stay home? Get a job? If so, what job? Who wanted to hire a deaf person? I thought of the poster, 'Uncle Sam Wants You,' but did he mean me—someone who couldn't hear?

My deafness hadn't bothered me in the past but now I thought of so many things—the way I was politely passed over when someone in the church wanted something done, the quick snicker when I misunderstood something said to me, and other little things. If it was like that among people who knew me, what would it be like without Mama or someone here at school to make me feel like I was a person too? . . .

. . . I wanted to help with the war somehow. I could cook, sew, type, help out in nursing—anything else, I was willing to learn. I wanted to work with Uncle Sam, but did Uncle Sam want me?"

Mary Herring Wright, Sounds Like Home: Growing up Black and Deaf in the South *(Washington, DC: Gallaudet University Press, 1999), 274–75*

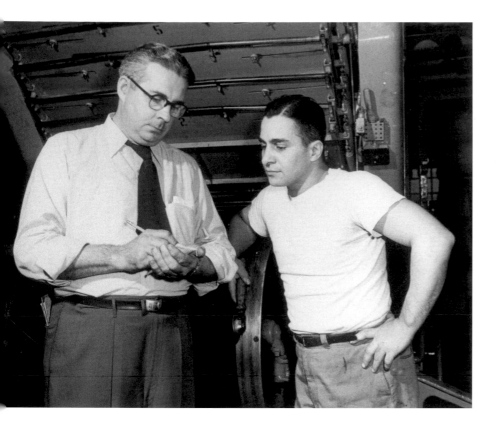

▲ This Firestone employee is communicating with his employer through writing. Firestone took photographs of its deaf workers and created a poster showing their "range of employability." (Gallaudet University Archives, Washington, DC; from the collection of Benjamin Schowe, Sr.)

▲ Tire building was one of the many jobs done by deaf workers at Firestone. (Gallaudet University Archives, Washington, DC; from the collection of Benjamin Schowe, Sr.)

◀ Robert Lankenau was a prominent deaf chemist who worked at Firestone. (Gallaudet University Archives, Washington, DC; from the collection of Benjamin Schowe, Sr.)

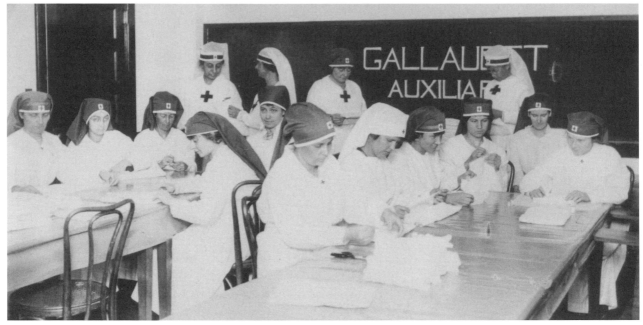

During World War I students at Gallaudet College formed a Red Cross Auxiliary. They cut, wrapped, and packaged bandages. (Gallaudet University Archives, Washington, DC.)

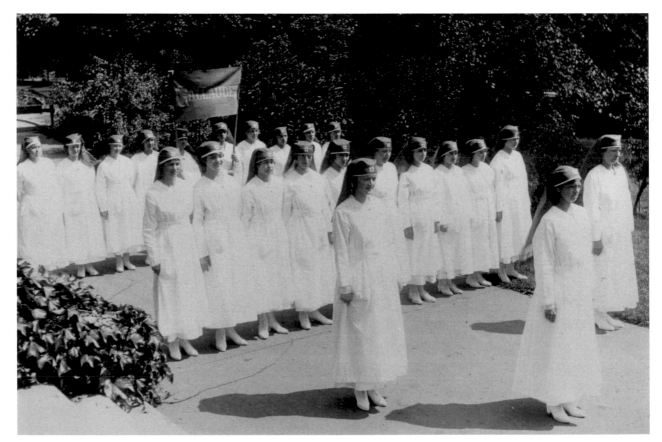

The Gallaudet Red Cross Auxiliary members wore nurses' uniforms while they performed their duties. They are seen here lined up for an official photograph during World War I. (Gallaudet University Archives, Washington, DC.)

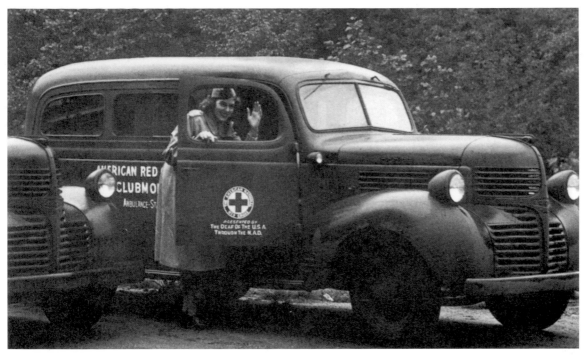

The National Association of the Deaf raised $7,771 to purchase three Red Cross Clubmobiles. (National Association of the Deaf, Silver Spring, MD.)

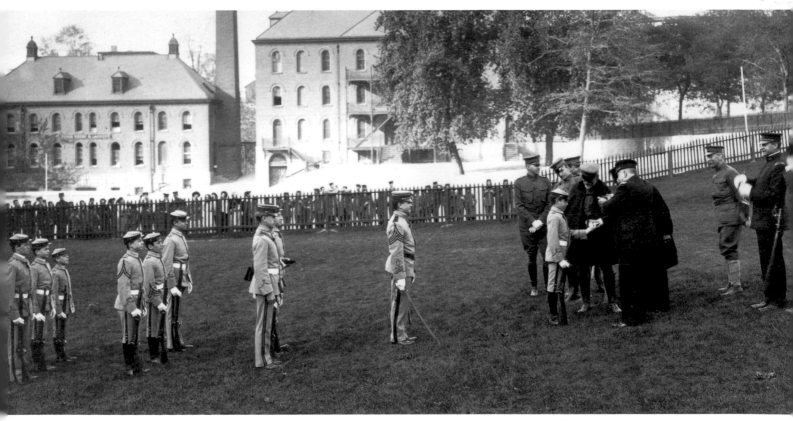

Award ceremonies modeled after those in the military were part of the academic experience at the New York School for the Deaf. (Gallaudet University Archives, Washington, DC.)

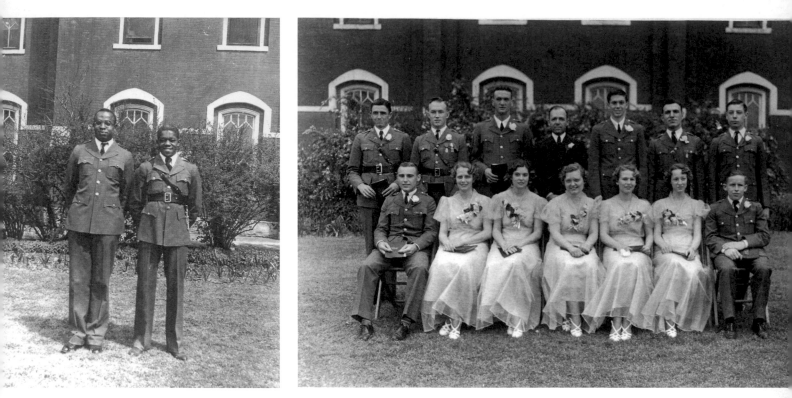

Male students wore uniforms for the 1937 graduation ceremonies of the Missouri School for the Deaf. The graduates were separated by race for their class pictures. (Missouri School for the Deaf, Fulton.)

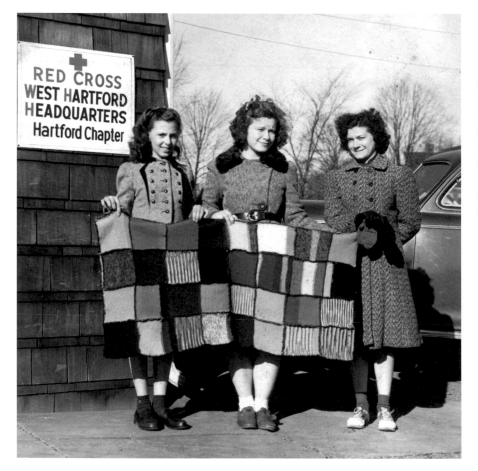

Students Florence Demeo (Zocco), Ann Fryxell (Weeds), and Virginia Marino (Szaly) from the American School for the Deaf in West Hartford, Connecticut, display a coverlet they are donating to the Hartford Chapter of the Red Cross, ca. 1941. (The American School for the Deaf, Hartford, CT.)

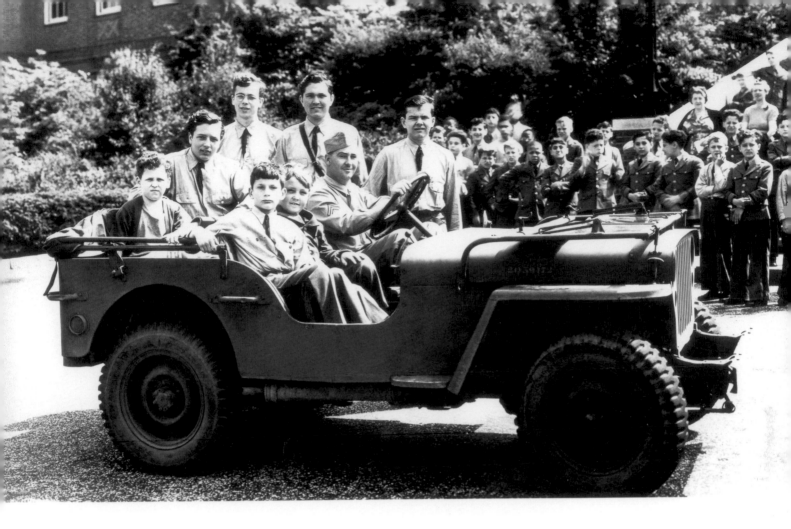

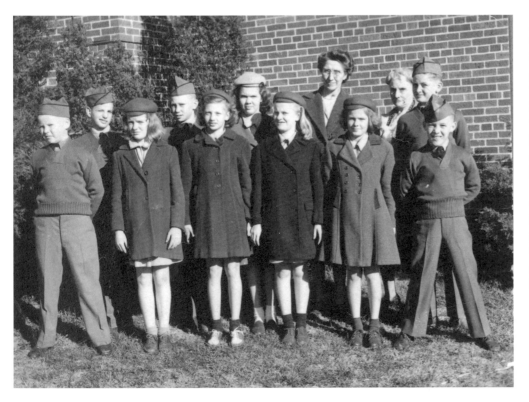

▲ Students from the New York School for the Deaf at White Plains pose with a soldier in this 1944 photograph. The school participated in the U.S. Treasury Department's "Schools at War" campaign. (From the collection of Robert J. Allen, courtesy of Dr. Barbara M. Kannapell.)

◀ Boys from the Missouri School for the Deaf dressed in military uniforms for this 1947–48 class photograph. (Missouri School for the Deaf, Fulton.)

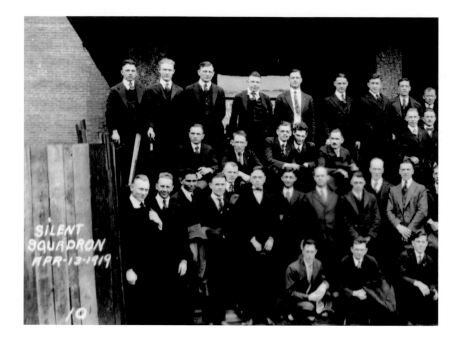

Members of the Akron Silent Club pose for their 1919 picture. The club remained open around the clock to accommodate shift workers. (University of Akron, Akron, OH.)

and women, many deaf people lost their jobs when returning servicemen displaced them and the factories converted to peacetime production. Not all were replaced, however. The wartime experiences of employers with deaf workers broke down many long-held prejudices, and deaf workers benefited from that exposure for years to come.

THE CLUB

In towns and cities across the country, deaf people established clubs that became centers for community life. In large cities, club members bought their own building, while in smaller towns they usually rented rooms over a downtown store. The glass door between two storefronts, through which stairs could be seen leading up to the second-floor club, became an iconic image of the Deaf club. The clubs served as a gathering place and watering hole as well as the site of social events as varied as performances by traveling comedians, captioned films, uplifting lectures, card games, dramatic performances, political

debates, storytelling, and holiday banquets. Most clubs also sponsored regular athletic events, picnics, and group outings. New York had at least twelve Deaf clubs, the largest of which was the Union League; many clubs were open daily to all comers. Some clubs specialized in particular activities, such as the Chicago Silent Drama Club, the Manhattan Literary Association of Deaf Mutes, and the Naismith Club of Brooklyn, a sports club named for the inventor of basketball.

Deaf clubs, like most associations of the time, were divided along ethnic and racial lines. The National Association of the Deaf had bylaws that limited membership to "any white deaf citizen," and local clubs followed suit. African American deaf people formed their own clubs, such as the Washington Silent Society, the Blue Jay Club in Los Angeles, the Ebony Club in Atlanta, and the Imperials Club in New York City. In smaller cities, they established less formal, sometimes unnamed clubs that used local churches or members' homes as meeting places. Jewish deaf people formed their own organizations as well, such as the

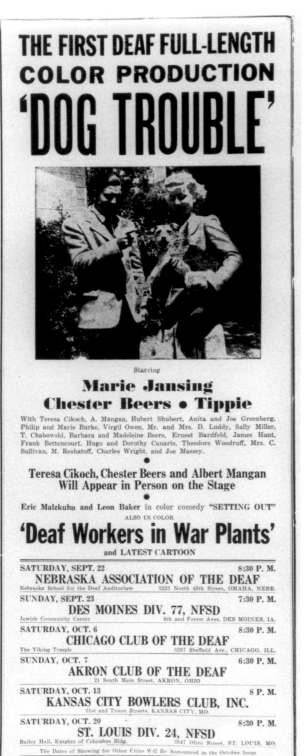

THE FIRST DEAF FULL-LENGTH COLOR PRODUCTION 'DOG TROUBLE'

Starring
Marie Jansing
Chester Beers • Tippie

With Teresa Cikoch, A. Mangan, Hubert Shubert, Anita and Joe Greenberg, Philip and Marie Burke, Virgil Owen, Mr. and Mrs. D. Luddy, Sally Miller, T. Chabowski, Barbara and Madeleine Beers, Ernest Bardfeld, James Hunt, Frank Bettencourt, Hugo and Dorothy Canaris, Theodore Woodruff, Mrs. C. Sullivan, M. Reshatoff, Charles Wright, and Joe Massey.

•

Teresa Cikoch, Chester Beers and Albert Mangan Will Appear in Person on the Stage

•

Eric Malzkuhn and Leon Baker in color comedy "SETTING OUT"
ALSO IN COLOR
'Deaf Workers in War Plants'
and LATEST CARTOON

SATURDAY, SEPT. 22 8:30 P. M.
NEBRASKA ASSOCIATION OF THE DEAF
Nebraska School for the Deaf Auditorium 3223 North 45th Street, OMAHA, NEBR.
SUNDAY, SEPT. 23 7:30 P. M.
DES MOINES DIV. 77, NFSD
Jewish Community Center 8th and Forest Aves, DES MOINES, IA.
SATURDAY, OCT. 6 8:30 P. M.
CHICAGO CLUB OF THE DEAF
The Viking Temple 3257 Sheffield Ave., CHICAGO, ILL.
SUNDAY, OCT. 7 6:30 P. M.
AKRON CLUB OF THE DEAF
21 South Main Street, AKRON, OHIO
SATURDAY, OCT. 13 8 P. M.
KANSAS CITY BOWLERS CLUB, INC.
31st and Troost Streets, KANSAS CITY, MO.
SATURDAY, OCT. 20 8:30 P. M.
ST. LOUIS DIV. 24, NFSD
Bailey Hall, Knights of Columbus Bldg. 3547 Olive Street, ST. LOUIS, MO.
The Dates of Showing for Other Cities Will Be Announced in the October Issue

For Bookings, Write
Gunnar E. Rath, 3912 Ames St., N. E., Washington 19, D. C.

Movies by deaf directors and producers, such as *Dog Trouble*, and captioned feature films brought large crowds to the Deaf clubs. (Gallaudet University Archives, Washington, DC.)

"Ask any Deaf person over the age of seventy what they remember about the years during the Second World War, and they are likely to tell of the big Deaf clubs, the large halls where Deaf people met on weekend nights to play cards, watch beauty pageants, or socialize around a bar with one of the club officers as bartender. . . .

. . . Home movies made in the heyday of Deaf clubs show tournament games followed by huge gatherings of Deaf people celebrating in large halls, lifting up drinks and cheering for the photographer. . . . In these home films we see shot after shot of packed halls and busy bartenders. With so many people crowded together in one place, one can begin to imagine a nation of Deaf people, clustered in Deaf clubs across the country."

Carol Padden and Tom Humphries,
Inside Deaf Culture (Cambridge:
Harvard University Press, 2005), 78–79

Jewish Society of Deaf Mutes in New York, which in some cities played an important role in acclimating new deaf immigrants to American life.

The clubs served several social functions. Deaf people who had grown up in oral schools often made their initial contacts with signing members of the Deaf community in clubs. There they could "learn to be Deaf" and discover the pleasures of easy and relaxed conversation. Many club members in these years were described by themselves and others as "ex-oral," with an approving nod indicating a difficult but common life path that turned out all right in the end. The clubs also provided information and assistance to deaf travelers and new arrivals in town; newcomers needed only the address of the local club to find a warm welcome, a place to stay, and help finding a job. The club often was the first stop in a

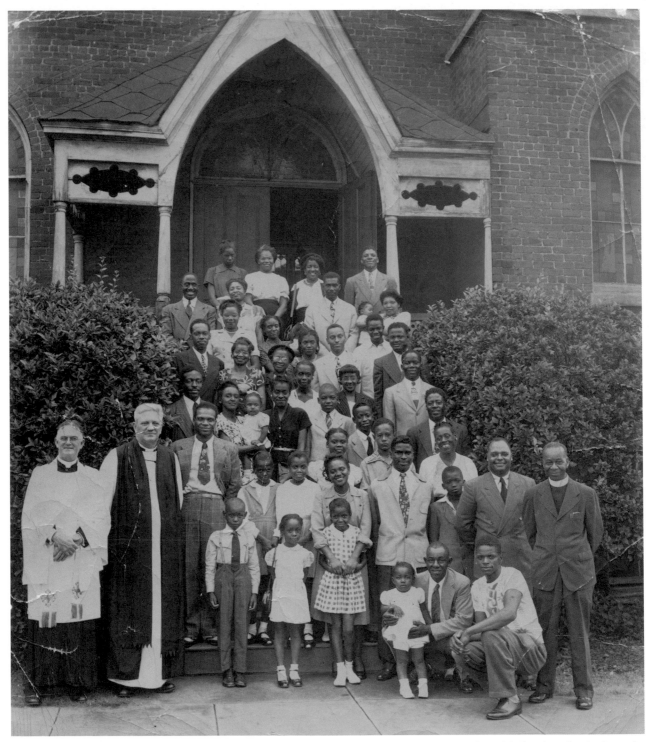

Not all deaf communities had clubs. Some churches served many of the same purposes and provided a place for deaf people to come together. This 1946 image shows black deaf congregants posing in front of St. Simon's Mission at St. Mark's Church in Birmingham, Alabama. The Reverend Robert Fletcher (*bottom row, far left*) was a deaf Episcopal priest who served both black and white deaf congregations in nine Southern states. (Gallaudet University Archives, Washington, DC; from the collection of Rev. Robert and Mrs. Estelle Caldwell Fletcher.)

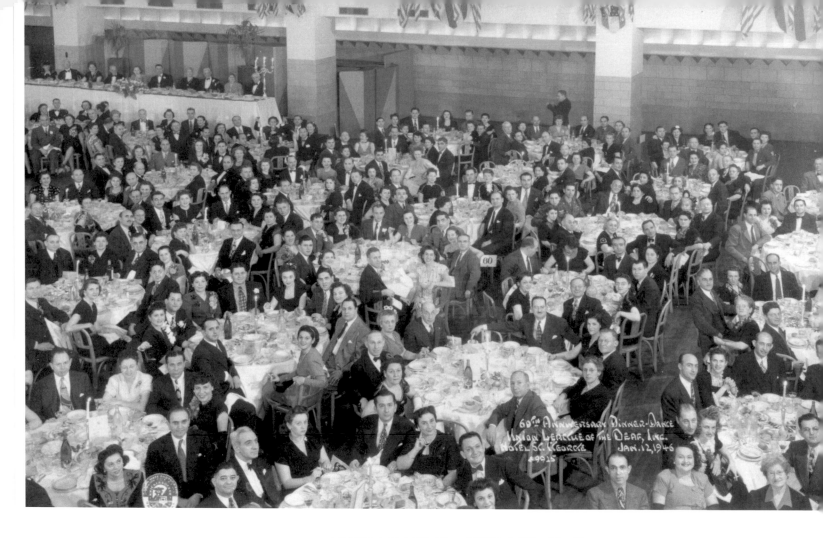

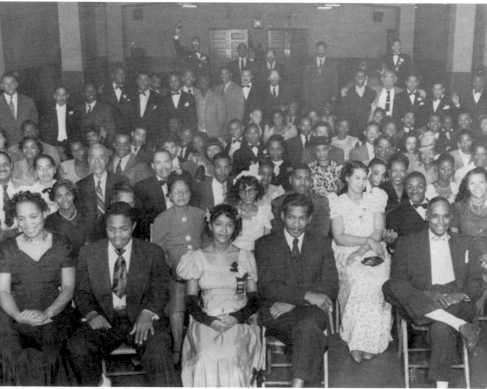

▲ In 1946 the Union League of the Deaf in New York City celebrated its sixtieth anniversary. Hundreds of members attended the gala dinner-dance. (Gallaudet University Archives, Washington, DC; from the collection of the Union League.)

▶ Deaf clubs were racially segregated. Clubs from different cities would occasionally host joint events, such as this May Dance of the Philadelphia and Washington, DC, Silents Clubs in 1947. (National Black Deaf Advocates, courtesy of Pamela Baldwin.)

CHAPTER SIX

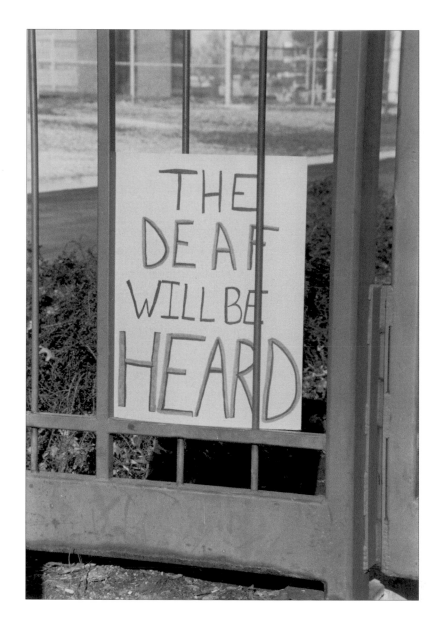

Access and Awareness

In the years following World War II, the United States experienced rapid social and economic change. Returning soldiers, an increased workforce and the baby boom brought the need for new housing and jobs. Those same returning soldiers would displace many Deaf workers in factories, just as women and others who had served the war effort from home lost their jobs.

Newspapers, magazines, and television brought news into American homes daily, and with it came awareness of the disparity of income and rights. The civil rights movement of the 1960s used marches, sit-ins, and protests as tools for change, and it inspired many minority groups, including the Deaf community, to press for self-determination and better economic opportunity. As many Americans came to accept greater cultural diversity, deaf people began to explore more openly their cultural-linguistic identity and assert their right to access information. They stressed the need for interpreting services, film and television captioning, and telephone access. New technologies, in medicine as well as communications, changed the experience of being deaf and the ways deaf individuals communicate with each other and people everywhere. Among the most significant of the changes was academic and community acknowledgment of a distinct, visual language.

◀ This sign was posted in one of the campus gates during the 1988 "Deaf President Now" revolution at Gallaudet University. (Gallaudet University Archives, Washington, DC.)

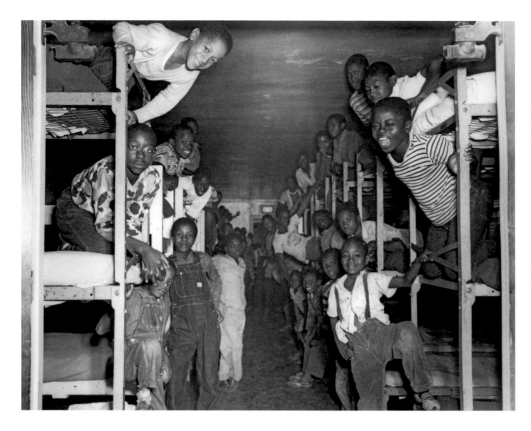

◀ African American students in segregated schools often had overcrowded and underfunded facilities. These students attended the Alabama School for the Negro Deaf at the McMillan Street campus from 1945–1947. (Alabama School for the Deaf, Talladega.)

▼ Elementary school students from a racially integrated Kentucky School for the Deaf pose for their class picture. (Kentucky School for the Deaf, Danville.)

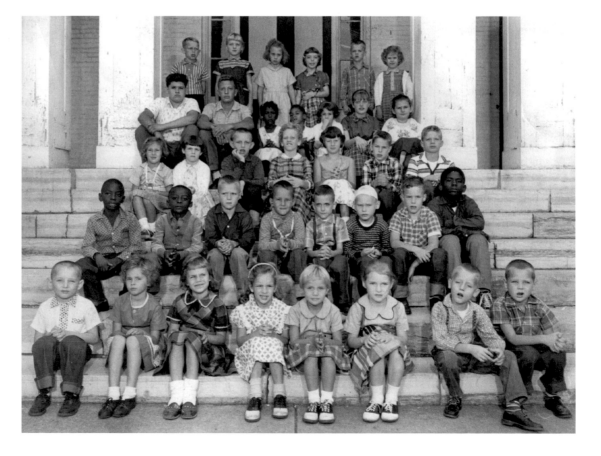

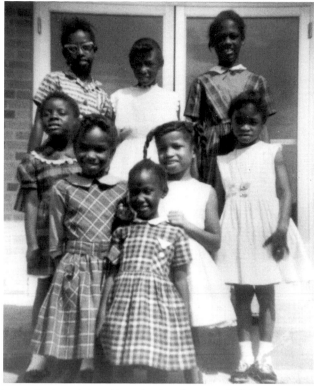

Lynda Carter, pictured here in pigtails, attended the segregated Madison Street School and then moved to the Arkansas School for the Deaf in 1963. She recalls that when she and her classmates "moved from the black school on Madison Street to the Arkansas School campus, the white house mother didn't know how to take care of black hair. She made us shampoo every day and my hair went back to its natural state!" (Courtesy of Lynda Carter.)

in Arkansas, illustrates the challenges black deaf students faced when they moved to integrated schools.

When the students arrived, the supervisors had us line up to quickly evaluate how intelligent we were and to immediately assign us to whatever program we were to attend. They would test us through signs, not with pencil and paper. It's a good thing I had picked up a lot from the adults and I could sign pretty well, but still my education was way behind. My signs were much better than my writing and I could fool them with how well I could sign. I was put into a slightly more advanced class.

Other black students were put in the vocational programs because they were not good signers. I wondered why all my friends went into the vocational program and I was put into a more academic program. When I went in there, all the students were white. I was the only black student in my class and I was also older than the other children. But my teacher looked at my writing and said, "You're very late for your age in writing." So I had to practice writing every day and pick up what I could to move along and progress. Then I finally got to be with students my age and I was learning very quickly.

I asked about my friends in the vocational program and I thought they were so lucky. When I got done with the

desegregation often meant sharing not only a classroom but also a dormitory.

Examining the pivotal moments of desegregation for deaf children opens a window on understanding race in America. In this microcosm of society, students' experiences reveal the circumstances when a common bond may help to break down ingrained racism and when that bond is overridden by race. Linguistic differences, educational disparity, and racism all had an impact on the lives of African American children during the integration process. The following story by Lynda Carter, a student at both the segregated and integrated programs

"At the Black Deaf school, our Black Deaf culture flourished. We had basketball games. We had our dances. We had Black teachers. Moving then to the white Deaf school—we all used sign language but the signs that were being used were very different."

Carolyn McCaskill

▲ Interpreting services have made it possible for deaf people to participate more fully in the political process, such as this public hearing. Janet Bailey is interpreting for Senator Edward M. Kennedy (D-MA). (Sign Language Associates, Silver Spring, MD.)

▶ Arthur Roehrig, who is deaf-blind, participates in a session at the Smithsonian Folklife Festival using tactile, hand-on-hand, interpreting. (Photograph by Virginia McCauley; Gallaudet University Archives, Washington, DC.)

Interpreting is provided not just for deaf people but also for the hearing people engaged in conversation. Hearing people are able to exchange information with deaf people through interpreting. Here an interpreter is "voicing" for reporters who are interviewing Gallaudet student Jerry Covell during the Deaf President Now protest of 1988. (Photograph by Jeff Beatty; Gallaudet University Archives, Washington, DC.)

TECHNOLOGY AND SOUND

Throughout the latter half of the twentieth century, a host of technological advancements, many of which took advantage of residual hearing, became available to deaf people. Progressively smaller and lighter weight hearing aids were developed. The early electronic hearing aids of the 1950s required large, heavy batteries and came with instructions on how to discretely tuck batteries into underclothing. Later versions could be stored in a pocket or clipped to a belt, and eventually they could be worn behind the ear.

Not all technological developments have been universally accepted by the Deaf community. The cochlear implant has inspired both strong support and vehement opposition. Among deaf people, the implants are generally hailed as a boon for individuals who lost their hearing later in life, but their use for deaf children has been controversial. The effectiveness and risks of the implants are a major part of the debate, but there is an additional conflict between those who view deafness as a physical impairment and those who see it as a valued part of cultural identity. As cochlear implant surgery has become more common

A student wearing a cochlear implant works with his teacher at the Clarke School–Center for Oral Education. (Photograph by Jennifer P. Burdick; Clarke School for the Deaf–Center for Oral Education, Northampton, MA.)

in deaf children, the emphasis of the debate has changed. The focus now is on the child's exposure to visual language and the type of support and educational services the child receives.

A cochlear implant consists of external and internal parts. The external components include a very sensitive, small microphone designed to pick up speech and environmental sounds, a speech/sound

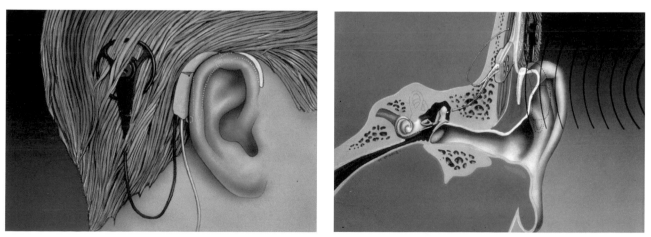

The external component of a cochlear implant includes a microphone worn behind the ear, a speech processor, and a coil that is placed on the skin behind the ear. The coil sends signals to the internal piece, the cochlear implant. When the microscopic hair cells in the cochlea are unable to stimulate the auditory nerve endings that are located in the inner ear, the auditory nerve, which connects the cochlea to the cortex of the brain, is unable to transmit sounds to the brain. A cochlear implant is designed to do the job of hair cells and stimulate the auditory nerve fibers in the cochlea for people who have sensorineural deafness. (Cochlear Corporation, Englewood, CO.)

▲ Media coverage of the Deaf President Now revolution helped to galvanize public support. Local and national press and television crews covered the story daily. (Photograph by Chun Louie; Gallaudet University Archives, Washington, DC.)

◀ On Thursday of the week-long protest, Dr. I. King Jordan, with his wife Linda by his side, spoke to the protesters and announced his support of their demands. (Photograph by Patsy Lynch; Gallaudet University Archives, Washington, DC.)

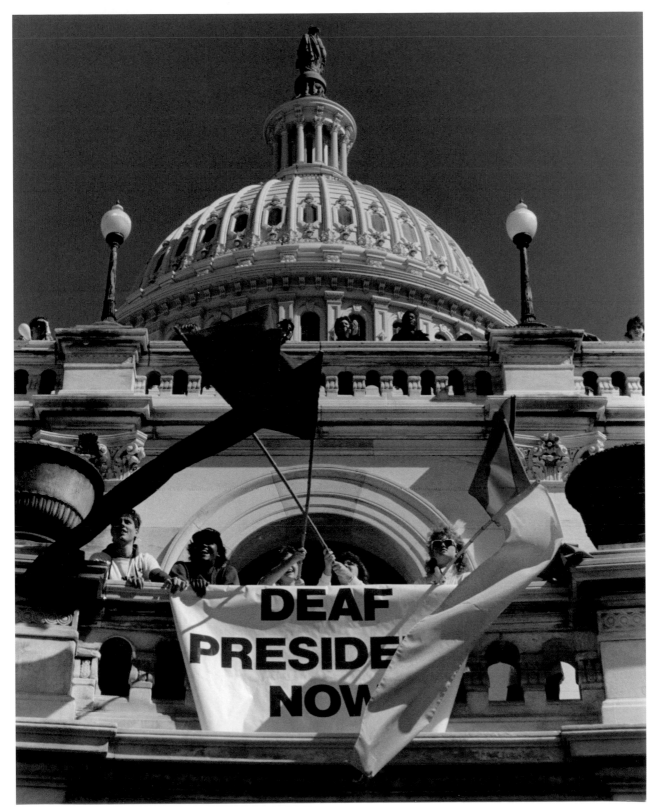

On the steps of the U.S. Capitol, students waved a "Deaf President Now" banner. (Photograph by Chun Louie; Gallaudet University Archives, Washington, DC.)

The Deaf President Now revolution was successful for a number of reasons. The association of DPN with previous civil rights struggles played an important role, as did the strong support of many Gallaudet faculty, staff, students, and alumni; others in the Deaf community (including interpreters); local community groups; legislators; and representatives of the mass media. The goals of the protest were timely, persuasive, and clearly defined, and articulate, charismatic student leaders emerged to communicate these goals to the nation.

"When I talked to my kids about what happened they were so surprised. 'There was a hearing president?!'"

Dwight Benedict

LAW AND ACCESS

"This is the emancipation proclamation for disabled Americans."

Senator Tom Harkin (D-Iowa)

In July 1990, the broadest legislative bill concerning the civil rights of people with disabilities became law when President George H. W. Bush signed the Americans with Disabilities Act (ADA). The ADA made discrimination based on disability illegal in employment, public transportation, public programs, telecommunications, and public accommodations such as restaurants, hotels, shopping centers, and offices.

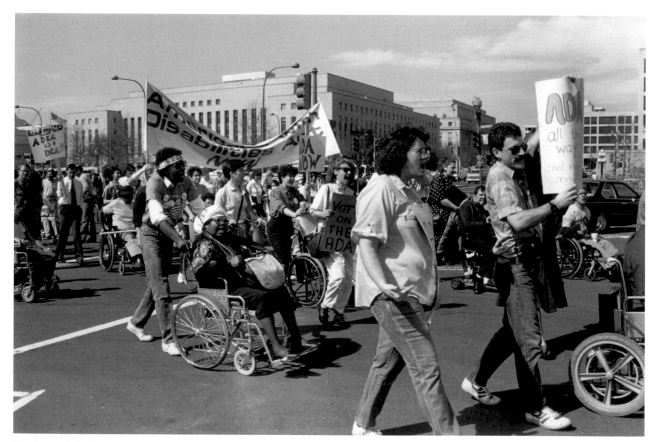

Deaf people joined with disability groups to march in support of the Americans with Disabilities Act in 1990. (Gallaudet University Archives, Washington, DC.)

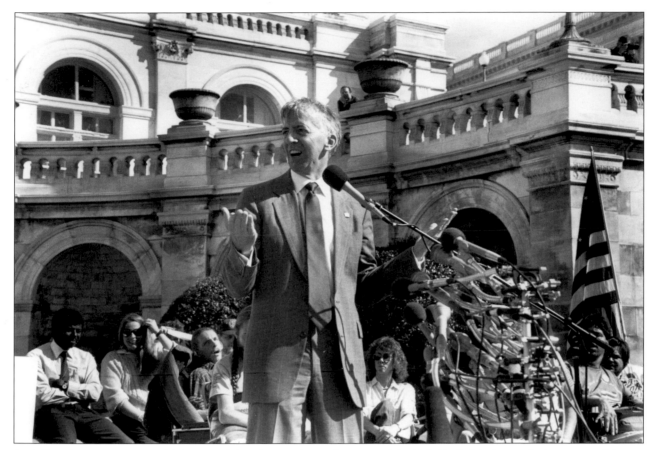

Dr. I. King Jordan, president of Gallaudet University, speaks on the steps of the U.S. Capitol during a rally in support of the Americans with Disabilities Act, 1990. (Gallaudet University Archives, Washington, DC.)

"The National Association of the Deaf, working with key disability advocacy organizations, was instrumental in pushing for the passage of the Americans with Disabilities Act of 1990."

Nancy J. Bloch, Executive Director
National Association of the Deaf

Deaf people joined forces with the disability rights movement to push for passage of the Americans with Disabilities Act. For deaf people, this law would mean access to public telephones and public events such as festivals, tours, and plays. Doctor's appointments and other meetings became more accessible through interpreting services, and television programs, rental videos and DVDs, and some publicly shown films became available to a much wider audience through captions. In order to see the "closed captions" on a television screen, though, consumers had to purchase a decoder that then had to be connected to the television.

Decoders benefited not only deaf people but hard of hearing people, young readers, and those learning English as a second language. However, the equipment was expensive and difficult to hook up.

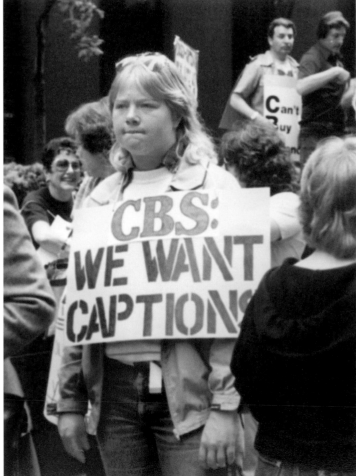

▲ The *ABC Evening News* with Peter Jennings was the first evening news program to include closed captions. (Courtesy of ABC News; National Captioning Institute, Vienna, VA.)

▶ In 1984, deaf protesters outside CBS headquarters in New York City called for captions. Deaf people, largely through the efforts of the National Association of the Deaf, continue to fight for captioning of more television programs, films, and DVDs. (Gallaudet University Archives, Washington, DC.)

For 36 years, this group in Maryland has met at each other's homes to watch captioned films and videos. (Photograph by Barry E. Bergey; Gallaudet University Archives, Washington, DC.)

Consequently, following passage of the Americans with Disabilities Act, the Deaf community turned its attention to a new law, one that would mandate inclusion of a decoder chip in new televisions. An array of professional, social, and political action organizations of deaf people worked together to ensure passage of the Television Decoder Circuitry Act in 1990. This law required all new television sets with a screen thirteen inches or larger to incorporate closed-captioning technology. As a result, deaf people no longer needed to go to the Deaf club to watch captioned films, something they had done since 1949. For the first time, they had independent access to TV news and entertainment programs; they could catch the evening news along with everyone else.

"Technology has really had a strong influence on us. Now we can watch TV and see things that are captioned. It's easier to sit down in the living room and watch TV than get in your car and drive to your local group where they had an old 16 mm projector to see a film. Now we will just turn on the TV and the captions are there. It's great, but it takes away from the fellowship."

Jack R. Gannon

CHANGING WITH THE TIMES

As the twentieth century came to a close, deaf people were faced with a bewildering variety of contradictory trends. The battle for social acceptance of ASL largely had been won. More people, not only deaf but also hearing, were using ASL than at any time in its history. Elementary schools, high schools, colleges, and universities offered ASL classes, and hearing people had more access to ASL than ever before. The number of residential schools and urban private day schools for deaf students that used ASL in the classroom increased dramatically, as did the hiring of deaf teachers. At the same time, fewer and fewer parents chose to send their children to special schools. The widespread acceptance of sign language led indirectly to the decline of separate residential schools, long the locus and transmission site of Deaf culture, by making it possible for deaf students to be mainstreamed with sign language interpreters, most of whom used one or another variety of signed English. As a result, young deaf people had less direct access to ASL.

After the Deaf President Now movement, Gallaudet University began to hire more deaf faculty and staff and to emphasize ASL fluency in hiring decisions. A newly established Deaf Studies Department began training scholars to provide and document a multidisciplinary analysis of the culture and history of the Deaf community. Gallaudet was more than ever a worldwide center for Deaf culture. At the same time, the Americans with Disabilities Act mandated accessibility on other campuses, which had the effect of dispersing deaf students around the country and forcing Gallaudet to compete for the best applicants.

Schools for deaf students around the United States realized the need for historical preservation and created museums to display local history and celebrate their past. At Gallaudet, the Archives expanded to become an important research center with the largest collection of material about deaf people in the world. Scholarship on the history of the Deaf community grew in sophistication and scope.

In 1989, Gallaudet University hosted "The Deaf Way," an international conference and festival celebrating Deaf language, culture, history, and art. The event drew 5,000 people from 80 countries and sparked many connections among Deaf people. One result of The Deaf Way was the creation of Deaf History International, an organization that fosters the exchange of information across national boundaries.

Other centers of Deaf culture, such as the centrally located Deaf club, had been undermined by economic and technological developments. Beginning in the 1970s, employment opportunities for deaf people expanded to a variety of professions and trades, which meant fewer deaf workers were concentrated in particular industries. As a result, the Deaf club lost its importance as a source of employment contacts. The dispersal of deaf workers into workplaces with less predictable and uniform schedules meant that the urban Deaf clubs could less easily serve as an after-hours meeting place for shift workers. Deaf professionals found new allegiances and associations that better suited their interests and needs.

Advances in communication technology made it much easier for deaf people to contact each other as well as the larger world around them. In particular, access to mass media served to undermine clubs, which were no longer necessary as sources of information and entertainment. While most see greater access as a positive development, many also regret the loss of beloved institutions of the Deaf community.

I know there are people who think that with genetics, with technology, and with changes that will happen in the future, deafness will disappear. I don't believe it. I think there will always be deafness and there always will be a need for people who are not deaf to understand deaf people.

I. King Jordan

The challenges faced by the Deaf community seem to multiply year by year. Yet surely when Veditz and the National Association of the Deaf launched their film project in 1910 to rescue the "noble language of signs," the challenges they faced then must have seemed equally daunting. ASL and the American Deaf community have been counted out before yet have survived in the face of countless difficulties and obstacles. Schools across the country have recently celebrated their 150th and 175th anniversaries with large and enthusiastic homecoming crowds. The American School for the Deaf will reach the two century mark in 2017, which also will effectively commemorate the 200th anniversary of this unique American community. The story is not nearly over, and future books will be needed to tell it.

Afterword

Remarkable things happen when a community history is presented. People find each other. Parallels are noticed. Departed community members and loved ones are remembered in the context of their times. For the Deaf community, perhaps the most dramatic moment comes when hearing people start to realize that a community exists at all.

When we started this project we wondered if anyone would care about Deaf history. What would it mean to the community and, more importantly, to the wider, hearing society? During a very early planning meeting, a colleague asked, "Why should I care?" It was an intentionally confrontational question meant to prod us to seek the most profound and persuasive reasons for creating an exhibition, or a book, or a film.

We learned that a wide spectrum of people care a great deal about this history. Naturally, the Deaf community has an interest and celebrates new knowledge about itself. Hearing people with important connections to deaf children and adults—family members, friends, neighbors, teachers, clergy, and service providers—seek a deeper understanding of the history of Deaf life. Historians are intrigued by the parallels between this and other minority communities. Scholars in the growing fields of Deaf Studies and Disability Studies welcome material that they can build on, challenge, and reinterpret according to their own lights. However, the most surprising

◀ Each host of the History Through Deaf Eyes exhibition included local objects. Here, American School for the Deaf (ASD) archivist Gary Wait (*right*) places a vitrine (glass case) over documents and objects from the ASD Museum for the 2001 opening. (Gallaudet University Archives, Washington, DC.)

Sam Supalla addressed a large gathering at the University of Arizona opening in 2004. As with all openings, the presenters and the exhibit stressed local history. (Courtesy of Todd Hlavacek.)

▲ The Birmingham Civil Rights Institute (BCRI) hosted History Through Deaf Eyes in Alabama in 2004. Gallaudet University Board of Trustees Chair Dr. Glenn Anderson (*left*), BCRI President Dr. Lawrence J. Pijeaux, Jr. (*center*), and Gallaudet President Dr. I. King Jordan (*right*) opened the exhibit. This installation stressed local Alabama stories, including issues of racial segregation in schools for deaf children. (Courtesy of Jean Bergey.)

◀ During the exhibit's stay at the University of Iowa in 2005, one family found a photograph of their mother/grandmother on display. (Courtesy of Rosalyn Lee Gannon.)

interest has come from those many members of the public who have no immediate connection to deaf individuals but who have found this story fascinating and compelling. The history of Deaf life, they have discovered, tells us not just about deaf people but about us all. The Deaf community has a distinctive way of perceiving the world; its history offers all Americans a fresh way of understanding the history of their country.

Hundreds of people cared so much about the public presentation of Deaf history that they wrote impassioned letters to the Smithsonian Institution (one of the hosts of the exhibition tour and a collaborator in its early stages), to express both vehement opposition and enthusiastic support. Their letters helped to guide the development of the exhibit, leading it to better represent the rich diversity of Deaf life.

When the History Through Deaf Eyes exhibition went on tour, each of the twelve sites took the national story and made it local by adding objects, images, and documents unique to the area. In Hartford, Connecticut, organizers drew on the extensive collection from the American School for the Deaf to mount an installation focusing on the nation's first permanent school. In Philadelphia, the Pennsylvania School for the Deaf added original paintings from artist and alumnus John Carlin for the installation at the magnificent Arthur Ross Gallery at the University of Pennsylvania. In Akron, Ohio, a dedicated group of Deaf people worked tirelessly to incorporate local Goodyear and Firestone history into the exhibit they installed at the Summit County Chapter of the American Red Cross, an organization with which the Deaf community forged strong connections during World Wars I and II.

Each host found a unique angle on history. The Missouri School for the Deaf (MSD) and William Woods University collaborated on an outstanding installation that drew on the MSD museum collection curated by Richard and Marthada Reed. In addition to some amazingly well-preserved objects, the museum loaned personal items from one of MSD's most famous alumnae of the nineteenth century, the writer and poet Laura Redden. In Rochester, New York, the Rochester Museum and Science Center worked with the Rochester School for the Deaf and the National Technical Institute for the Deaf to present local history. The Colorado School for the Deaf and the Blind was the only school that installed the exhibition on its campus. The location allowed the school to recreate a dorm space and include many large objects used in the early vocational training provided at the school. Colorado was also the only location that addressed the historic link between deaf and blind students who share a campus. Nashville was unique in holding History Through Deaf Eyes in a public library. The

▲ The Smithsonian Institution's Arts and Industries Building, in conjunction with the National Museum of American History, displayed History Through Deaf Eyes during the international conference and festival Deaf Way II (July 2002). An interpreter skilled in international gestural communication made the text of the exhibit accessible to deaf visitors who did not read English. (Courtesy of Jean Bergey.)

▼ In July 2004, Beijing Union University, College of Special Education, with the support of the university's president, Xu Jia Cheng, installed a set of posters based on History Through Deaf Eyes, translated into Chinese. The posters have traveled to a number of locations throughout rural and urban China. (Photograph by Hu Ke, courtesy of Lan Qing.)

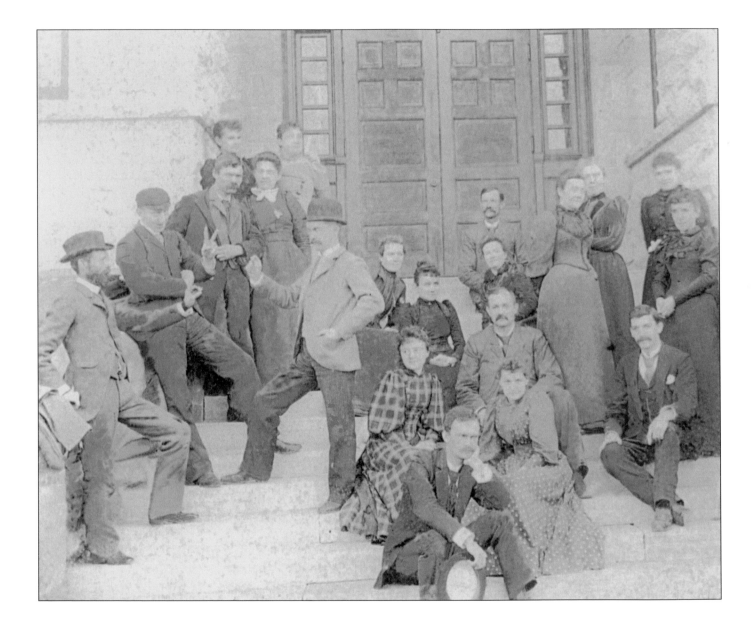

Acknowledgments

Through Deaf Eyes is the product of hundreds, even thousands of people. We want first to acknowledge the person who inspired the title of the book, the documentary film, and the exhibition: George W. Veditz, who wrote in 1910 that deaf people "are first, last, and all the time the people of the eye." Our title is meant as a reminder of the visual nature of Deaf life; even though hearing people often think of deafness as simply an absence, it is often more a matter of difference.

Many units on the Gallaudet campus supported this project, but particular thanks go to the Department of History and Government, the Department of ASL and Deaf Studies, Institutional Advancement, Gallaudet University Archives, Television and Media Production Services, Academic Technology, Gallaudet Interpreting Services, and, especially, the Office of the President.

Dr. I. King Jordan, Gallaudet University's president from 1988 through 2006, supported the project when we struggled with controversy and funding. His unwavering dedication to the presentation of Deaf history made it possible to share an extraordinary story with the public.

Andrea Shettle was a Gallaudet sophomore in 1989 when she suggested the idea of an exhibition on Deaf life. Her spark lit the flame that years later became the History Through Deaf Eyes exhibition. The exhibition inspired the documentary film *Through Deaf Eyes* and this book. We cannot thank her enough.

We thank John Christiansen for his important contributions to the sections of the book on the Deaf President Now revolution and cochlear implants. His expert knowledge in these areas added much to the text.

Advisors to the project guided, critiqued, and offered ideas, contacts, and inspiration. Authors of histories quoted within this book conducted the painstaking research without which this book would have been impossible. Interviewees from the film punctuate the pages with both personal and academic analysis on a broad range of topics.

In the tiny Deaf Eyes office at Gallaudet University, students Shelby Jia and Jiale Jia created a library of photographic images and designed web pages. Melissa Allen helped to keep us organized. Bridget Klein and Lynn Crawford listened and offered feedback on issues big and small. Members of the ASL/Deaf Studies faculty responded to questions, reviewed drafts, and made an adjunct office welcome in their space.

Dr. Jane K. Fernandes provided crucial support, participated in exhibit openings, and most of all, allowed the project to move forward when our financial footing was less than stable. Her deep appreciation of history and her understanding of the impact of sharing Deaf life with a broad audience made all the difference.

We thank Michael Olson and Ulf Hedberg of Gallaudet University Archives for helping us to plumb their holdings. Their knowledge of the collection and enthusiastic support of the project were indispensable. Many other archival sleuths, people who care deeply about the preservation of history,

◀ The officers and teachers of the Colorado School for the Deaf posed for this 1892–1893 school photograph. George Veditz (*far left, on the steps*) is signing V for Veditz. Also seen signing their initials are D.C. Dudley (D) and Joseph A. Tillinghast (T). (Courtesy of the Colorado School for the Deaf and the Blind, Colorado Springs.)

made important contributions. Almost every school for deaf students, it seems, has someone who sees the value in preserving and presenting history. Individuals too numerous to mention here provided personal family photographs. To all of you, we are grateful.

We thank our editor at Gallaudet University Press, Ivey Pittle Wallace, for sure-footed guidance and advice, and Jill Porco for keeping the process rolling. John (Vic) Van Cleve has given steadfast support to the exhibition, film, and book since it was just a kernel of an idea. He offered historical knowledge, publishing expertise, and safe-keeping for the hundreds of visual materials that we collected along the way. His role cannot be overstated.

This book is first and last a photographic narrative. Most of the photographers are unknown and unnamed, but their keen eyes saw moments to capture and, for that, we are very much in their debt. Many of the photographs became meaningful only when we could identify people or describe the events caught on film. Help in this regard came from Harry Lang, Eric (Malz) Malzkuhn, Mervin D. Garretson, Lynda Carter, Jerald (JJ) Jordan, Pyllis Frelich, Bobby Fletcher Ray, Mabs Holcomb, Gary E. Wait, Astrid Goodstein, Kathie Gonzalez, and Karyn Zweifel.

This book is a companion vioume to the documentary film *Through Deaf Eyes*, a production of WETA Washington, DC, and Florentine Films/Hott Productions, in association with Gal-laudet University. Heartfelt thanks go to filmmakers Lawrence Hott and Diane Garey of Florentine Films/Hott Productions, producers of the two-hour film. They spent years researching a complex and controversial subject, produced a vibrant and creative documentary, and brought Deaf history to a vast and new audience. They were willing to venture into territory where few hearing people have gone, and we are all richer for it.

At WETA TV in Washington, D.C., Executive Producer Karen Kenton developed the documentary film project and saw it through from start to finish. Karen's insight and thoughtful commentary helped to shape the film and all of the companion products, including this book. Dalton Delan, Executive Vice President and Chief Programming Officer, offered keen analysis of the story and guided us to the core messages for viewers. WETA's President and CEO Sharon Percy Rockefeller recognized the potential to educate in *Through Deaf Eyes* and gave her support to the project, even participating in the advisory panel meeting. Collaboration brought support from multiple internal WETA offices, all of which worked in sync to produce, promote, and distribute the first nationally broadcast film on Deaf history. We are profoundly grateful.

Personally, we thank our families for providing the love and sustenance to keep us going and the wise counsel to pull us from our keyboards.

Credits

This book is based in part on research conducted for the History Through Deaf Eyes exhibition, and we thank the following organizations for their support of that effort:

National Endowment for the Humanities
The Motorola Foundation
The John S. and James L. Knight Foundation
SBC Foundation
The Rockefeller Foundation
The Goodrich Foundation
Gallaudet Research Institute

MAJOR FUNDING FOR THE DOCUMENTARY *THROUGH DEAF EYES* WAS PROVIDED BY

National Endowment for the Humanities
Corporation for Public Broadcasting
Public Broadcasting Service
The Annenberg Foundation
National Endowment for the Arts

ADDITIONAL FUNDING WAS PROVIDED BY

Sign Language Associates, Inc.
Richard and Gail Elden

The film, *Through DEAF EYES*, for which this book is a companion volume, is a production of WETA Washington, DC, and Florentine Films/Hott Productions, in association with Gallaudet University. The two-hour documentary was produced by Lawrence Hott and Diane Garey, written by Ken Chowder, narrated by Stockard Channing, and inspired by the curatorial work of Jack R. Gannon. Senior advisor to the project is Harry G. Lang. Contributing filmmakers are Kimby Caplan, Wayne Betts, Jr., Arthur Luhn, Andrean Mangiardi, Tracey Salaway, and Rene Visco. Executive producers are Karen Kenton and Dalton Delan.

Index

Page numbers in italics denote photographs and illustrations.

ABC Evening News, 138
ADA. *See* Americans with Disabilities Act of 1990
African Americans, 42–45, 47, 104, *106, 107. See also* racial segregation
Akron, Ohio, 92–93; employment in, 93–97
Akron Club for the Deaf, 93, *104*
Alabama Association of the Deaf, 92
Alabama School for the Deaf, *30, 32, 34,* 98, *99*
Alabama School for the Negro Deaf, *118*
Alexander Graham Bell Association, 116
American Annals of the Deaf, 50, 70, 81
American Association for the Promotion of Teaching Speech to the Deaf, *62*
American Athletic Association of the Deaf, 6
American Instructors of the Deaf, *67*
American Mutoscope and Biograph company, *6*
American School for the Deaf: etching of second building, *11*; girl students in early photo, *17*; integrated classes, *43–44*; method of instruction, *16*; shoemaking at, *35*; 200th anniversary of, 141; during wartime, *102. See also* Connecticut Asylum for the Education and Instruction of Deaf and Dumb Persons
American Sign Language (ASL): defined, 3; misconceptions about, 3–4; origin of, 3; during period of oralism, 82; poetry, 5, 34; preservation of, 80–82, 83; racial dialects, 44–45; recognition of, 114–17, 140
Americans with Disabilities Act of 1990 (ADA), 7, 124, *136–37,* 136–39, 140
Applied Communications Corporation (APCOM), 122
Arkansas Optic (school newspaper), 77
Arkansas School for the Deaf, 117, *119*
ASL. *See* American Sign Language
AT&T, 121
automobiles and driving, 90–91, *91*
Ayers, Lew, *111*
Ayres, Jared, 52

Backus, Levi, 48
Bahan, Ben, *114*

Bailey, Janet, *126*
Ballin, Albert, 82, 110
Bartlett, Leonard, *35*
Bauman, H-Dirksen L., 15
Baynton, Douglas C., 76
Bell, Alexander Graham, *62,* 70–75, *71, 73, 75,* 115
Bell, Mabel Hubbard, *73*
Benedict, Dwight, *133,* 136
Bingham, Katharine, 68
Bloch, Nancy J., 137
Boer, Adrianus, Helena, and Helene, 76
Booth, Edmund, 32, 51, *51*
Braidwood Academy, 12–13
Bravin, Philip, 133
Breunig, H. Latham, 122, *122*
Bridgman, Laura, *22*
British Sign Language, 3
Brown v. Board of Education (1954), 117
Bryan, William Jennings, 88
Buchanan, Robert M., 47, 87, 89, 90
Burch, Susan, 86
Bureau of Immigration, 75
Burnet, John, 22

Canajoharie Radii (newspaper), 48
Carlin, John, 52, 53
Carter, Lynda, 119, *119,* 121
Casterline, Dorothy, *114, 115*
Chamberlain, William, 48
Chaplin, Charlie, *109,* 110
Children of a Lesser God (film), *111,* 117, *117*
church. *See* religion
Civilian Conservation Corps (CCC), 86–87
civil rights movement, 113, 136
Civil Service jobs, 87–90
Civil Service Reform Act of 1883, 87
Clarke, John, *65*
Clarke Institution for Deaf Mutes, 64, *65,* 71. *See also* Clarke School for the Deaf
Clarke School for the Deaf, *38, 79;* Center for Oral Education, *127*
Clerc, Eliza Boardman, 15
Clerc, Laurent: address to Connecticut Legislature, 18; on political oppression of deaf persons, 50, 51; role in deaf education, 11, 13, *13,* 16; speech at opening of Gallaudet

College, 53; travel to U. S. and founding of Connecticut Asylum, 14, *15*
closed captioning, 7, 137, *138–39,* 139
cochlear implants, 127–29, *127–29*
Cogswell, Alice, 12, *12*
Cogswell, Mason Fitch, 11, 12, *12*
Colorado Index (school newspaper), 77
Colorado School for the Deaf and the Blind, *61*
Columbia Institution for the Deaf and Dumb and Blind, 52
Confer, P. H., 50
Connecticut Asylum for the Education and Instruction of Deaf and Dumb Persons, *12,* 14, *17;* Reports of the Directors, 16–17, 23. *See also* American School for the Deaf
Covell, Jerry, *126*
Craig, Douglas, *57*
Crawford, Joan, *111*
Crider, Summer, *129*
Croneberg, Carl G., *115*
Crouch, Barry, 49, 69, 83
Cullingworth, William R., *11*
Curtis, Elmer Ivan, *41*

Darwin, Charles, 64
Deaf clubs, *104–5,* 106, *107;* Alexander Graham Bell's criticism of, 74; decline in importance of, 139, 140; at educational institutions, 37; establishment of, 104–8; role of church in, *106;* role of, in Deaf community, 6, 45–47
Deaf communities, 8–9, 14–15; formation of, 2, 29–59, 74, 83; religion in, 23–24
Deaf culture, 4–6, 34, 83, 125, 140
deaf education: adoption of sign language in, 25–27; age of admission, 20–21; change of terminology on, 25, *40;* curriculum of, 34–42, *36;* establishment of state schools, 18–23; founding dates of schools (1817–1860), 19; origin of, 11–27; superintendents' role, 21; transformation in, 55. *See also* oralism; residential schools; *specific schools*
deaf immigrants, 75–76
Deaf-Mute (Kentucky), 49
Deaf Mute (North Carolina), 49, 77
Deaf-Mute Advance (Illinois), 49
Deaf-Mute Gazette (Boston), 48

Deaf-Mute Index (Colorado), 77

Deaf-Mute Mirror (Michigan), 49, 77

Deaf-Mute Optic (Arkansas), 77

Deaf-Mute's Advocate (New York), 77

Deaf-Mutes Journal, 48

Deaf-Mute Times, 49

Deaflympics, 6

Deaf President Now, *113*, *126*, 129–36, *130*, *131*, *133–35*

Deaf press and publications, 6, 47–49

Deaf republic, proposal for, 50–51

Deaf Way conference (1989), 140

Debs, Eugene, 88

Demeo (Zocco), Florence, *102*

Democracy in America (Tocqueville), 45

Denison, James, 68, *69*

Desloges, Pierre, 14, *15*

Dictionary of American Sign Language on Linguistic Principles (Stokoe, Casterline, & Croneberg), *115*

Dog's Life, A (film), *109*

Dog Trouble (film), *105*

dormitory life, *30*

Draper, Amos, 40

driving licenses, 90–91, *91*

Ducks (Gallaudet alumni group), *130*, *131*

Dudley, Lewis, 64

Education for All Handicapped Children Act of 1975, 125

employment: Civil Service jobs, 87–90; in deaf schools, 30; during Depression, 85–87; post-ADA opportunities, 140; post-World War II, 113; wartime jobs, 92–104

employment training. *See* residential schools; vocational training

ethnic deaf clubs, 104–5

eugenics, 71, 74, 75

evangelical Protestantism, 23, 27

federal employment, 87–90

film: portrayal of deaf persons, *109*, 109–11; series by National Association of the Deaf, 4, 82, *83*, 141; of signed National Anthem, *vii*, 6, 109

fingerspelling, 2, 4, *34*

Firestone Tire and Rubber Company, *85*, 92, *96–97*

Fischmann, Moische, 76

"flag rush" at Gallaudet University, 57

Fletcher, Robert, *59*, *106*, 109

Flournoy, James J., 50–51

folklore, 5

folk remedies for deafness, 20, 21

For the First Time (film), 111

Frat, The (magazine), 108

Fraternal Society of the Deaf, 108

Frelich, Phyllis, *117*

French Sign Language, 3

Froehlich, Theodore, 47

Frye, Rubye, *120*

Fryxell (Weeds), Ann, *102*

Gallaudet, Edward Miner, 45, 51–55, *52*, *54*, 69, 88

Gallaudet, Thomas (son of Thomas Hopkins Gallaudet), 108

Gallaudet, Thomas Hopkins, 11–14, *12*; education of, 11; European travels of, 12–14, 25; founding of Connecticut Asylum by, 14; Gallaudet College named in honor of, 53; on goal of education, 27; religious teachings of, 23–24; on sign language, 26

Gallaudet Camp, *58*

Gallaudet College. *See* Gallaudet University

Gallaudet Guide and Deaf-Mute's Companion (newspaper), 48

Gallaudet Home for the Aged and Infirm Deaf, 108

Gallaudet Red Cross Auxiliary, *100*

Gallaudet University (formerly Gallaudet College), vi; Archives of, 140; buildings, *52*; as center of Deaf culture, 140; Deaf President Now protest, *113*, *126*, 129–36, *130*, *131*, *133–35*; establishment of, 51–59; hiring of deaf faculty and staff, 140; name change to, 53; students, *54–59*

Gannon, Jack R., 48, 69, *69*, *139*

Gannon, Rosalyn Lee, *117*

Garretson, Carol, *6*

Garrett, Emma, 66

Gillett, Philip, 44

Glyndon, Howard. *See* Searing, Laura Redden

Goodstein, Harvey, *132*

Goodyear Silents, 92, *94*, *96*

Goodyear Tire and Rubber Company, 92, *93–96*

Great Depression, 85–87

Greenwald, Brian, *70*

Groce, Nora Ellen, 8–9

Hanson, Olof, 89

Harkin, Tom, 136

Harmon, Kristen, *7*

Harrison and Norton Club (Gallaudet College), *54*

hearing aids, 127

The Heart Is a Lonely Hunter (film), 110, 111

Hellers, Peter N., Jr., 108

Herran, Dorothy, *85*

Hodgson, E. A., 48

Holcomb, Roy, 7

Hughes, Coach, 56

Humphries, Tom, 44, 105, *115*

Illinois School for the Deaf, 44, *65*

immigration: of deaf persons, 75–76; as impetus for oralism, 63–64

integration of schools, *43*, *44*, 117–21, *118*, *119*, *120*

intermarriage among deaf persons, 71, 74

interpreters, 75, 125, *126*, 140

Iowa School for the Deaf, *41*

Jennings, Peter, *138*

Jewish deaf people, 104–5

Johnny Belinda (film), 110, *111*

Johnson, Alphonso, 55

Johnson, Lyndon Baines, *125*

Jones, C. J., *114*

Jordan, I. King, *131*, *133*, *134*, *137*

Jordan, Linda, *134*

Joyner, Hannah, 50

Kansas School for the Deaf, *31*

Keller, Helen, *73*

Kelser, John H., 63

Kendall, Amos, 51–52

Kendall School, *39*, *120*

Kennedy, Edward M., *126*

Kentucky Deaf Mute (newspaper), *41*

Kentucky School for the Deaf, *19*, *32*, *42*, *93*, *118*, *120*

Kentucky Standard (newspaper), *41*

Kisor, Henry, 8

Krauel, Charles, 108

Krentz, Christopher, 55

Lane, Harlan, 125

language and communication, 1. *See also* American Sign Language; sign language

Lankenau, Robert, *97*

Laurent Clerc National Deaf Education Center, *52*

L'Epée, Abbé de, 13, 16, 17

Lexington School for the Deaf, *62*

Lincoln, Abraham, 53

lipreading, 2, 6, *6*, 7–8. *See also* oralism

literary societies, *5*, 104

literature of American Deaf community, 4–5

Little Paper Family, 49, 76–79
Long, J. Schuyler, 82
Lord's Prayer lithograph, 24
Louisiana School for the Colored Deaf and Blind, 42
Lovella (Benson), Ruth, 66

Madison Street School (Arkansas), 117, 119
Maginn, Francis, 63
Mainstreaming, 124–26, 128, 140
Malzkuhn, Eric, 111, 111
manualism, 20, 61, 64, 66–67. See also sign language
Manually Coded English, 4
Man Who Played God, The (film), 110
Marino (Szaly), Virginia, 102
Marr, Thomas, 109
Marriage: An Address to the Deaf (Bell), 75
marriage among deaf persons, 71, 74, 75
Marshall, Ernest, 99
Marsters, James C., 121–22, 122
Martha's Vineyard, 8–9, 16
Marvelli, Alan, 74
Massieu, Jean, 13
Matlin, Marlee, 128
McCaskill, Carolyn, 119
McGowen, Mary, 68
McGowen Oral School, 68
McGregor, Robert, 64, 109
media coverage: Deaf President Now protests, 130, 134; portrayal of deaf people, 109–11, 117. See also newspapers; television
medical attempts to "cure" deafness, 20, 21, 127–29
Medoff, Mark, 117
"Memoir upon the Formation of a Deaf Variety of the Human Race" (Bell), 71, 74
Mentor, The (periodical), 77
methodical sign language, 4, 16
Mexico (New York) Independent (newspaper), 48
Michigan Mirror (school newspaper), 77
Michigan School for the Deaf, vii, 25, 108
Milan Congress, 68–70, 69
military-style activities in schools, 98, 99, 101, 103
Minnesota School for the Deaf, 29
Miracle Worker, The (film), 110
missionaries, 23–24
Missouri School for the Deaf, 31, 102, 103
motion picture industry. See film
Mt. Airy World (school newspaper), 77
Mute's Chronicle (Ohio), 49, 77
Myers, Carol Grosvenor, 114–15

NAD. See National Association of the Deaf
Nanney, Elva, Ruth, Nora, and Matthew, 30
National Association of the Deaf (NAD): Automobile Bureau, 90; on cochlear implants, 129; on deaf president for Gallaudet University, 130; donations to Red Cross, 101; efforts to obtain closed captioning, 138; establishment of, 46, 46–47; film series to preserve sign language, 4, 82, 83, 141; official publication of, 79; opposition to oralism, 81; and passage of ADA, 137; role of, 6, 46–47; seeking employment opportunities for deaf persons, 86, 88, 89; segregation in, 104; state associations connected with, 92
National Deaf-Mute College, 53. See also Gallaudet University
National Fraternal Society of the Deaf, 6, 108
National Technical Institute for the Deaf (NTID) Act of 1965, 125
National Theatre of the Deaf, 116, 116
nativism, 64
New England Gallaudet Association of Deaf-Mutes, 45–46, 50, 109
New England Home, 109
newspapers: Deaf press, 6, 47–49; school papers, 39–40, 40, 41, 76–79
New York City clubs, 104–5
New York Institution for the Improved Instruction of Deaf Mutes, 62
New York School for the Deaf, 31, 99, 101, 103
North Carolina Institution for the Deaf, Dumb, and Blind, 49
North Carolina School for the Blind and Deaf, 42–43, 44
North Carolina School for the Deaf, 34, 36
North Carolinian (school newspaper), 77
North Dakota School for the Deaf, 21, 35, 37, 38, 39
Northern New York Institution for Deaf-Mutes, 77

occupations of deaf people, 39–41
Ohio Chronicle (school newspaper), 77
Ohio Home for the Aged and Infirm Deaf, 109
Ohio School for the Deaf, 41; Alumni Association, 108–9
Oklahoma Industrial Institution for the Deaf, Blind, and Orphans of the Colored Race, 42
Oklahoma School for the Deaf, 30
"Old" Fowler Hall, 52
Oliva, Gina, 74, 124

Olmsted, Frederick Law, 53
Olson, Gary, 132
oral communication, 2–3, 6–8, 7. See also oralism
oralism, 61–83, 62, 65; and Alexander Graham Bell, 70–75; and concept of normality, 66–68; immigration as impetus for, 63–64; methods of instruction, 65, 66, 78–81; and Milan Congress, 68–70; rise of, 61–63; and social Darwinism, 64–66
Oregon Outlook (newspaper), 41
Oregon School for the Deaf, 41
Osbrink, Rory, 128

Padden, Carol, 44, 63, 105
Paris, France: deaf community, 9, 14, 15; school for deaf students, 13, 14
Peet, Harvey, 27
Pennsylvania Institution for the Deaf and Dumb, 20
performance art, 5
Pettengill, Benjamin, 81
Philadelphia Silents Club, 107
poetry in ASL, 5, 34
political autonomy of American Deaf community, 50–51
Porter, George S., 49, 77, 79
Porter, Sarah, 63
prayers and hymns in sign language, 24, 25
preparatory (first-year) students at Gallaudet, 54
"The Preservation of the Sign Language" (film), 82, 83
printing trade, 39–40
Protestantism, 23, 26, 27

racial segregation: in deaf organizations and clubs, 47, 104, 107; at Gallaudet University, 57; integration of schools, 117–21, 118; at Kendall School, 120; at Kentucky School for the Deaf, 120; in residential schools, 42–45, 102, 118
The Radii (newspaper), 48
Red Cross Auxiliary at Gallaudet, 100
Red Cross donations, 99, 101, 102
Redmond, Granville, 109
Registry of Interpreters for the Deaf (RID), 125
religion: influence on deaf education, 23–24, 25–27; Jewish deaf clubs, 104–5; prayers and hymns in sign language, 24, 25; Protestantism, 23, 26, 27; in residential schools, 32; role of churches, in deaf clubs, 106
residential schools, 29–34; advantages of, 125;

residential schools (continued)
daily routine in, 29, *31*; decline of, 140; dormitory life, *30*; education in, 34–42, *36*; goals of, 22–23; health care in, *32*; newspapers in, 39–40, *40*, *41*; opposition to, 71, 74; religious routine in, *32*; segregation in, 42–45, *102*, *118*; teachers in, 40–41; vocational training in, *38*, *39*, 39–40, *41*, 85. *See also specific schools*

retirement homes, 108–9
Reynolds, George, 77
RID (Registry of Interpreters for the Deaf), 125
Rider, Henry, 51
Robinson, Warren, 86
Rochester Institute of Technology, *125*
Roehrig, Arthur, *126*
Roosevelt, Franklin Delano, 86
Roosevelt, Theodore, 88
Rosen, Jeff, *130*
Rosen, Ros, *131*
Royal Institution for Deaf-Mutes, 13
rubella, 124
Rubenstein, John, *117*
Rutherford, Susan D., 4

St. Mark's Church (Birmingham, Alabama), *106*
St. Mary's Institution for the Deaf (Buffalo, New York), *67*
Saks, Andrew, 121–22, *122*
Sanborn, Franklin B., 80
Sanderson, Robert G., *122*, 122
Schein, Jerome, 8
Schreiber, Frederick C., 120
Schuchman, John S., 110
Schuman, Anna, *29*
Searing, Laura Redden, *26*, 80
Searing, Stanley, 109
Sears, Heather, *111*
Second Great Awakening, and deaf education, 23–24
segregation. *See* racial segregation
Sicard, Abbé, 13
sign language, 1–2, *2*, *24*, *25*, *34*; controversy over, 61–83; creation of, 2, 3; in deaf education, 25–27; defense of, 80–83; as natural language, 66; rejected by educators in

1960s, 124. *See also* American Sign Language (ASL); oralism
Sign Language: A Manual of Signs (Long), 82
Sign Language Structure: An Outline of the Visual Communication Systems of the American Deaf (Stokoe), 114
Silent Worker (newspaper), 6, 49, *49*, 77, 79
Silent World (school paper), 48, 77
Singleton, Paul, *131*
Smithsonian Folklife Festival, *126*
social conformism, 66–68
social Darwinism, 64–66
South Carolina School for the Deaf, *2*, 43
South Carolina School for the Deaf and the Blind, 44
Spear, Anton, 63
speech. *See* oral communication; oralism
Spilman, Jane, 132, 133
sports, 6, 93, *94*, 104
"Star-Spangled Banner," signing of, *vii*, 6, 109
Stokoe, William C., Jr., 114–15, *114–15*
Storrs, Richard and Sarah, *16*
Story of Esther Costello (film), *111*
Sullivan, Anne, *73*
Supalla, Sam, *3*

Taft, William H., 88
Tales of the Deaf and Dumb (Burnet), 22
Tarra, Guilio, 69
Taylor, David, *123*
Taylor, Paul, 122, *123*
Taylor, Sally, 122, *122*, *123*
TDD (telecommunications device for the deaf), 121. *See also* TTYs and telecommunications
teachers: deaf teachers, 40–41, 74, 75, 140; early philosophy of, 23–24, 25–27; national organizations of, *46*; in residential schools, 35, 37, 40–41; women as, 79–80
technological advances, 127–29, 140. *See also specific devices*
Teegarden, George M., 63
Telecommunications Accessibility Enhancement Act of 1988, 124
Telephone/Teletype Communicators of St. Louis, 122

teletypewriters (TTYs). *See* TTYs and telecommunications
Teletypewriters for the Deaf, Inc. (TDI), 123
television: closed captioning on, 7, 137, *138–39*, 139; deaf characters on, 117; presenting National Theatre of the Deaf on, 116–17
Television Decoder Circuitry Act of 1990, 139
terminology, change in, 25
Texas School for the Deaf, *36*
theater, *111*, 116–17, *117*
Through DEAF EYES (film), vi
Tillinghast, Thomas, 29
tire industry. *See* Akron, Ohio; *specific tire companies*
Tocqueville, Alexis de, 45
TTYs and telecommunications, 7, 121–24, *122–24*
Tucker, Bonnie, 6
Tucker, Jamie, *116*
Turner, William, 50
typesetting and printing, 39–40, *40*, *41*, *41*

Union League of the Deaf, *107*

Van Cleve, John, 49, 69, 83
Veditz, George, 40, 82, *83*, 88, 88–89, 141
vocational training, *37*, *38*, 39–41, *39*, *40*, *41*
Voices (film), 111

Waite, Helen E., 114
Washington, D.C. Silents Club, *107*
Weiner, Fred, *131*, 132
Weitbrecht, Robert H., 121–22, *121–22*
Wing, George, 37, 66
Wingfoot Clan (Goodyear newsletter), *94*
women: as factory workers, *85*, 92, *94*, *95*; in Gallaudet's Red Cross Auxiliary, *100*; as teachers, 79–80
Woodruff, Lucius, 27
Works Progress Administration (WPA), 86
World Wars I and II, 92–104
Wright, Mary Herring, 43, 96
Wyman, Jane, *111*

Zinser, Elizabeth, 132, 133